LONDON CITY AIRPORT
AIRPORT
THROUGH TIME
Paul Hogan

AMBERLEY PUBLISHING

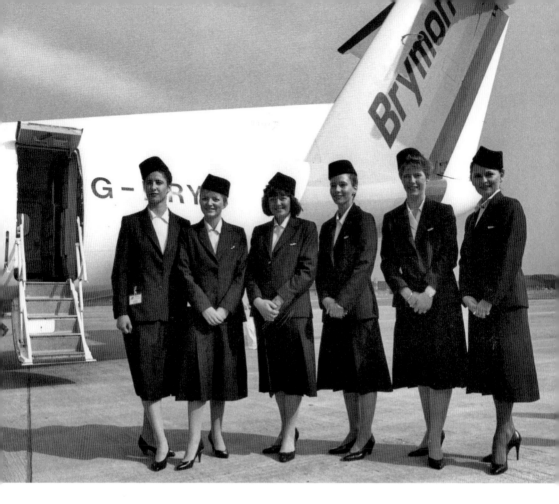

Brymon hostesses at London City during the airport's early days.

First published 2012

Amberley Publishing
The Hill, Stroud
Gloucestershire, GL5 4EP

www.amberley-books.com

Copyright © Paul Hogan, 2012

The right of Paul Hogan to be identified as the
Author of this work has been asserted in accordance
with the Copyrights, Designs and Patents Act 1988.

ISBN 978 1 4456 1047 4

British Library Cataloguing in Publication Data.
A catalogue record for this book is available from
the British Library.

Typeset in 9.5pt on 12pt Celeste.
Typesetting by Amberley Publishing.
Printed in the UK.

Acknowledgements

In the 25 years since London City Airport sent its first aircraft into the skies, the airport has changed far beyond the initial vision of those who it was possible to build such an airport in what is now the financial heart of London. Although there are numerous facts and figures one can cite about the airport, this airport, perhaps more than any other in the UK, has built up a very close relationship with the community it serves. Not for LCY the well organised protests and legal challenges faced by their much larger competitors. Indeed, an examination of the archive correspondence revealed a great deal of local support for the airport when it was first being proposed. This level of public support would be the envy of any other airport today even though many of the residents living around London City may never use it as the airport's schedules and prices are geared up to the needs of the business man rather than the holiday vacationer.

During my research for this book I am grateful for the help freely given by those who helped turn the vision into reality and in particular to Mr Stuart Innes of the London City Airport Consultative Committee, without whose help this book could not have been written. My sincere thanks to Stuart for letting me have access to the LCACC archive and for allowing me to reproduce many of the photographs herein. I would also like to thank some of my former BSc Aviation Management students from London Met University who after graduating secured work at the airport in a variety of roles and guises and in particular Mr Paul Miller, now of Delta Airlines, and Miss Laetitia Stephan, formerly of City Jet, for all their help. I would also like to extend my thanks to the many staff at London City Airport whom I have come across during my research for this book. In particular I would like to mention Mr Ben Harrison, another former student of mine but now the airport's Operational Safety Controller. Without his time and invaluable help and assistance and the cooperation of his colleagues, I really couldn't have done this.

A big thank you also goes to Peter Davison who recommended me to Amberley Publishing to write the book. I hope I have done them and the airport justice.

Finally, a big thank you to my wife Tanya for her help and support.

Paul Hogan
July 2012.

Foreword

The idea of having an airport in the heart of a metropolis is not a new one. Ever since Charles Lindbergh made his ground breaking and historic first solo flight from the USA to Paris, numerous schemes have been put forward to connect the major cities by 'highways of the air'. Fortunately for us, most if not all of these visionary ideas were more 'pie in the sky' rather than practical solutions, as this image of what Kings Cross might have looked like had the Aerophiles had their way shows! However, the dream of direct inter-city services has never really gone away and the idea of an inner London airport took off again – quite literally – in the late 1960s, when the *Daily Mail* suggested holding an air race between London and New York. This time the location was not Kings Cross but St Pancras as the dream of the 1930s was turned into a sort of reality. In May 1969 an RAF Harrier 'dropped in' to the old goods yard and took off again in a cloud of soot and coal dust to eventually land in New York some 5 hours and 45 minutes later. It was not the fastest crossing of the Atlantic at that time, that honour belonging to the Royal Navy's F4 Phantoms, but protagonists of Vertical Take-off flight were convinced that sooner or later VTOL airliners would be built in large numbers and traditional airports like Heathrow would eventually be digging up their runways and planting tomatoes! It will therefore come as no surprise to even the most sceptical observer that some 43 years later not one VTOL civil airliner has ever been built! So much for soothsayers, but while VTOL airliners remain a distant dream the need for better connections between major cities was still there.

Heliports were seen as one answer and in New York the famous Pan-Am building, located right in the heart of the metropolis, offered direct connections to their base at JFK. Not to be outdone, in London BEA offered flights from London City Hall, where the London Eye now stands, to Heathrow. Unfortunately, planning and noise restrictions

4

on the route prevented the helicopter flying in a straight line to Heathrow and it was forced to follow the River Thames, thus making it uneconomic to operate.

Another blind alley in this search for rapid transport was the Fairy Rotodyne. Part helicopter part aircraft, the Rotodyne offered much greater speed, range and payload, but the high-pitched noise made by the unique peroxide tip jets on the rotor effectively killed it off and it never went into production. However, London is an ever changing landscape and a new solution to the problem of direct connectivity was just around the corner – or to put it more accurately, down river in the old Royal Docks. Here they would find the perfect place for a new civil airport that didn't owe its origins to the military and it would be the first new runway to be built in Britain since the war.

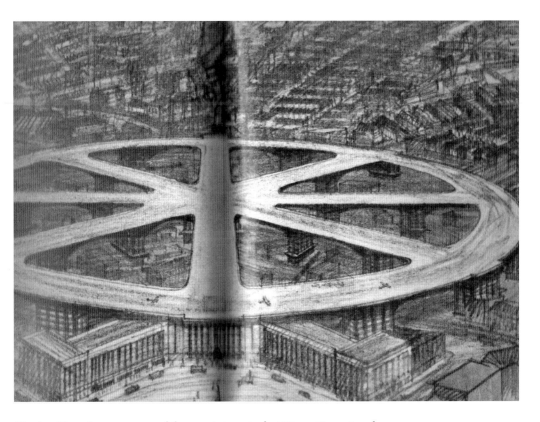

Charles Glover's 1935 proposal for an air terminal at Kings Cross, London.

First Steps

While the idea of VTOL airliners may have been proved to be a dead end, the idea of a city airport refused to go away and it was the application of another technical aviation device that allowed what follows in these pages to become a practical reality. I refer of course to STOL – or to give it its full title, Short Take-Off and Landing.

STOL is the key that unlocked the door to inner-city aviation. When Bill Bryman of Plymouth-based Bryman Airways saw the incredible performance of the then-new de Havilland Canada Dash 7 airliner at the 1978 Farnborough Air show he knew that here was an aeroplane that could offer the sort of point-to-point services he wanted to introduce.

With Plymouth's runway being less than 1,000 metres long, the Dash 7 could easily fly into and out of his base there, but more important to Bryson was its ability to operate out of the even shorter 600-metre airstrip at Unst in the outer Shetland isles. His plan was to cash in on the North Sea oil boom that relied on helicopters to fly oil men out to the rigs from Aberdeen. This was long flight by a 'chopper but only a short flight from Unst. A Dash 7 could be used transfer the oil men from Aberdeen to Unst, thus saving the oil companies both time and money. Chevron Petroleum bought into this idea and by 1982 Brymon had completed his airline's linkages when he started a regular service from Plymouth to Heathrow.

At about the same time as Bill Brymon was watching test pilot Tom Appleton land the Dash 7 in just 250 metres, the new government of Margaret Thatcher was wondering what to do with the now-redundant London Docks. Their answer was the creation of the London Docklands Development Corporation (LDDC), which was charged with the regeneration of the whole area and was to be given a virtually free hand in order to do so. This meant being effectively freed from local planning authority regulations

and political interference in order to bring forward an ambitious scheme to effectively move the financial heart of the City of London from its traditional base in the square mile to a new site at what would become Canary Wharf. In order to fulfil this ambition it needed some eye catching projects. The tall towers at Canada Square are the most obvious landmark; the driverless Docklands Light Railway (DLR) was another; and a dedicated Heliport was also put forward as a key piece of infrastructure. This was an idea which soon developed into a STOL airport but did anyone have any experience of such operations? None of the major UK airlines had and so the stage was set for a meeting with Brymon Airways to see how it could be done.

In 1981 the chief executive of the LDDC, Reg Ward, had a meeting with Sir Philip Beck, the chairman of John Mowlem & Co Plc, a company who had a long association with construction work in the Royal London Docks. By a happy coincidence, Sir Philip held a private pilot's licence and he knew about the Dash 7's capabilities for short take off and landing and it was suggested that a redundant wharf in the docks could be turned into an airstrip. This was just the sort of high profile idea that Reg Ward wanted and so contact was made with Bill Bryce in Plymouth who despatched his chief pilot, Captain Harry Gee, to see if this hair brained idea was at all possible.

Harry Gee was a former Royal Navy pilot who was used to landing on to the heaving deck of an aircraft carrier and so landing on a stationary airstrip would be no problem for him. Mowlem cleared away the rusty sheds and debris that littered this part of the docks and after discussions with the Civil Aviation Authority, the CAA granted permission for a test flight to see if it was indeed feasible to land an aircraft there.

On Sunday 27 June 1982, Harry Gee landed his Dash 7, G-BRYA *City of Plymouth*, on what is now known as Heron Quays. It was not only a successful trial landing but it attracted a tremendous amount of publicity for the LDDC

and of course Brymon Airways. More than that, though, it proved the practicality of the idea of a STOL port in this location and so the seeds of London City Airport were sown.

As Heron Quays is right in the centre of what we call Docklands and only a stone's throw from Canary Wharf and Canada Square, it became clear that a more suitable location for the STOL port needed to be found. The 800-foot-high tower was just too close for comfort and the site of the huge King George V and Albert Docks was chosen instead.

By the end of 1982 plans for the new airport were at an advanced stage. Brymon had shown the project was feasible, Mowlem said they could build it and the LDDC wanted it. In November 1982 LDDC sought planning permission and a Public Inquiry lasting 63 days took place the following June. This was a relatively quick decision when compared to Heathrow's Terminal 5 inquiry, which took nearly four years to complete!

In 1983 Bill Bryce sold his stake in Brymon Airways to a consortium which included British Airways. This could have proved to be detrimental to LDDC's plans but BA's Colin Marshall became an enthusiastic supporter of the new airport.

On 14 August 1984 Patrick Jenkin, in his role as Secretary of State for the Environment, wrote that he was 'minded to grant permission for a STOLport subject to certain conditions being met'. Most of these conditions related to operational aspects of the new airport such as noise controls, flight times and the banning of helicopters and general aviation from using the airport but two of them were more serious. The first of these restricted the length of the runway and by doing so, the type of aircraft that could operate from there. This restriction meant that only aircraft like the Dash 6 and Dash 7 could operate from there but as we shall see, the new airport would quickly outgrow these restrictions.

Although the local population was clearly in support of the new airport development, others were clearly not so well disposed towards it. In 1985 Ken Livingstone, the charismatic leader of the then-GLC tried unsuccessfully to overturn the airport's planning permission by trying to get the Public Inquiry reopened. That he failed in his bid is clear to see as the airport today is a hive of activity and far more successful than its founders ever envisaged. Later on, Mr Livingstone, ever the politician and now Mayor of London, obviously underwent a change of heart towards the airport as on 6 December 2006 he officially opened the DLR London City Airport Extension!

The original plan for the airport's runway shows it on a different alignment to that we can see today. Instead of running straight down the middle of the central dock area, the runway was aligned at slight angle in order to clear the 834-foot-high Canary Wharf Tower and the supporting structures of the proposed East London River Crossing.

This off-set alignment placed a severe handicap if there were to be any future plans to expand the airport and Richard Sainsbury, Mowlem's project director, successfully argued the case for 'throwing a life line' to the airport. He was able to secure the cooperation of the other developers in the LDDC who were keen to see the airport develop a range of European connections in order to serve the Canary Wharf development. To this end he was able to get an agreement with Olympia & York, one of the biggest developers in Docklands, to reduce the height of the main Canary Wharf tower to a more reasonable 734 feet above airport level. Also, as the East London River Crossing was at this stage only a proposal, he was able to get some concessions on the proposed design of the bridge and precedence for the airport which was fast becoming a reality. The effect of these two modifications should not be underestimated as they really helped to underpin the success of the airport. Sainsbury was concerned that as production of the Dash 7 had recently been terminated by its new owners, Boeing,

other types of Category 2 aircraft and in particular the BAe 146 should be able to use the runway. The removal of these two obstacles allowed aircraft approaches into the airport to fall from 7 degrees, ideal for a Dash 7, to the 5.5 degree glide slope a BAe 146 could easily manage.

Construction of the new airport continued throughout 1986 with the runway now fixed on its present day 10/28 alignment. When Prince Charles laid the foundation stone it became apparent to all who were there that this project was going to be seen through to a satisfactory conclusion. That conclusion became evident when a year later, on 26 October, Capt. Harry Gee flew Brymon Airways' first commercial flight from Plymouth into LCY.

While Brymon took the honour of the first flight *into* London City, the first flight *out* of the airport belonged to Euro City Express, who began operating a regular service to Paris. This rapid London–Paris service, perhaps more than any other, saw the fulfilment of a dream held by many for so long. Euro City Express was the brainchild of Sir Michael Bishop, the forthright chairman of British Midland Airways, who set up ECE specifically for routes flying from London City and who was pressing for permission for the BAe146 to be allowed to operate from there.

When formally opened by the HM the Queen on 5 November 1987, it had taken just six years and some £50m to turn this once derelict part of London into the first all-new airport to be built in Britain since the war. While seen by some at the time as an expensive white elephant, today the £50 million pound price tag can be seen as the bargain of the century and while the airport still has its small share of detractors, the overall opinion of the many travellers who use it find it to be a completely different and better experience to any other London airport.

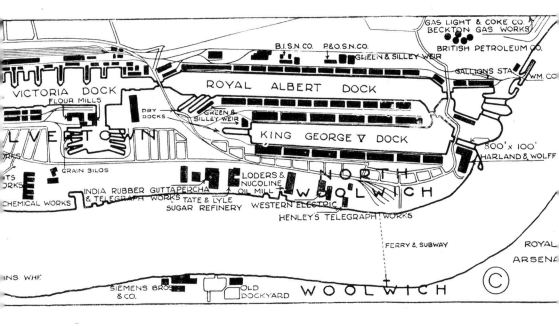

A map of the Royal Docks from a 1930 book of port plans, showing the Royal Albert and King George V docks. (J&C McCutcheon Collection)

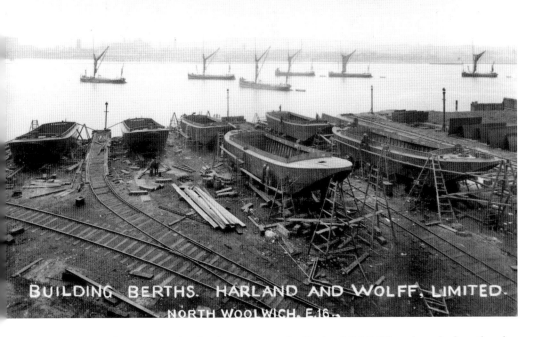

Barges under construction in about 1930 at the Harland & Wolff yard marked on the plan above at the mouth of the King George V Dock. (J&C McCutcheon Collection)

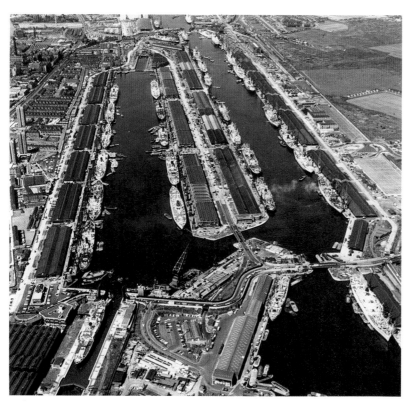

The once-busy docks in their heyday, *c.* 1958. Note the large number of ships present.

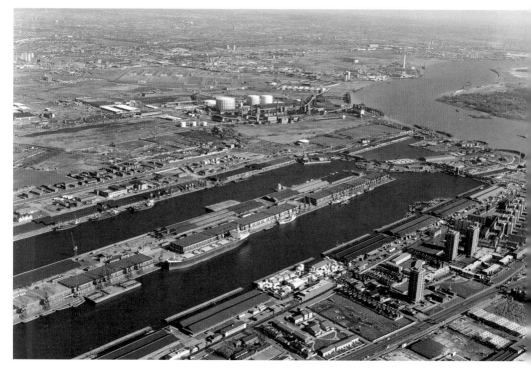

And into decline by the late 1980s.

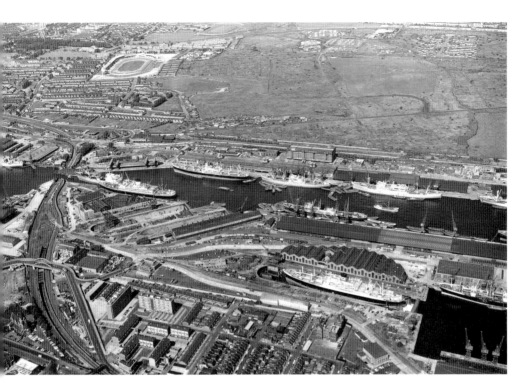

The ship in dry dock is where the new passenger terminal would be built.

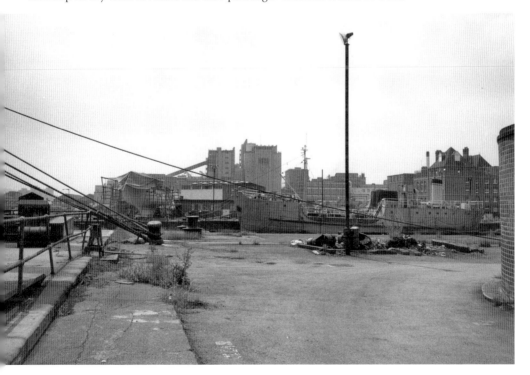

The defunct Heron Quays lying derelict, *c.* 1981.

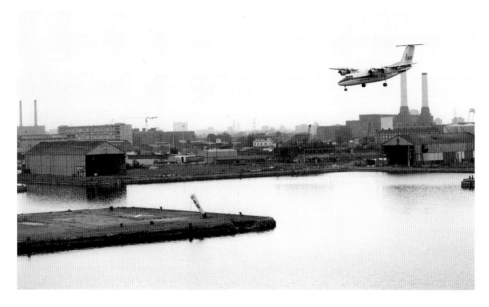

Brymon Airways Dash 7 making the first landing approach to Heron Quays.

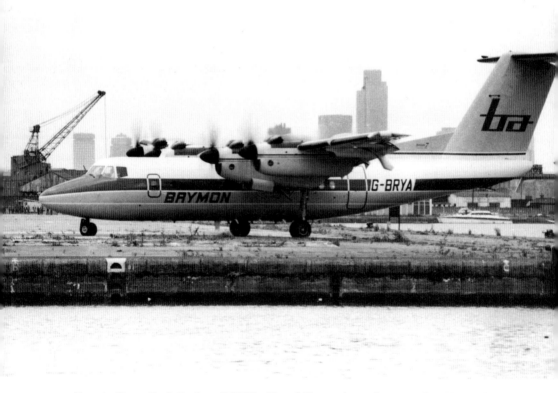

Captain Harry Gee's Dash 7, G-BRYA *City of Plymouth*, on the ground at Heron Quays, 27 June 1982.

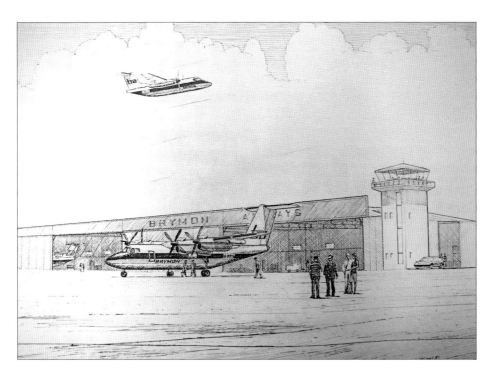

Mowlem's original ideas as to what the new STOL port would look like.

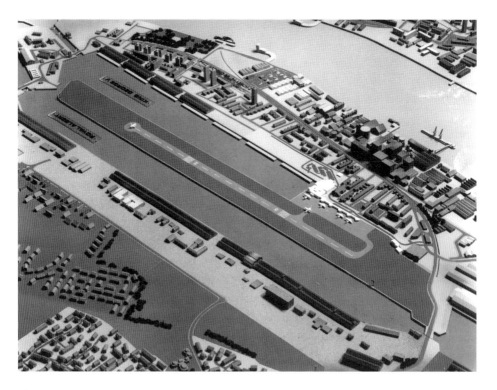

The model put together by Mowlem in 1985 to show what the airport would look like when completed.

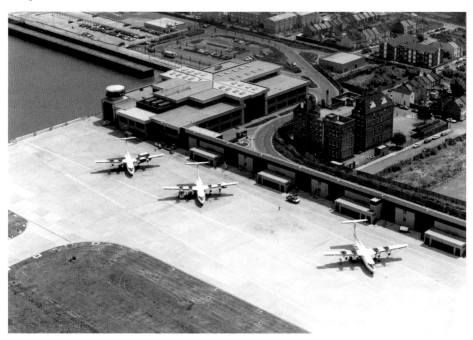

And how it turned out: the original terminal building and ATC tower at London City Airport.

Expansion and Growth

Even though the airport was restricted in the types of aircraft it could operate, passenger numbers continued to grow steadily and were nudging close onto 200,000 per year. Given the limited range of operation of the Dash 7 aircraft, it soon became apparent that they would have to apply for a variation of the original planning permission in order to extend the runway if the new BAe 146/Avro RJ series of jets were to be introduced to the airport.

The plan to introduce pure jet-powered aircraft at London City would open up a whole new range of operations and destinations for the airport. While the Dash 7 was an excellent commuter aircraft for routes like Manchester and Paris, its limited range meant that places like Aberdeen, Lyon and Frankfurt were at the top end of its range. However, a new generation of city jets were being planned by BAe Systems, Embraer and Bombardier Aerospace to tap into what was now being seen as a potentially lucrative market, markets that had been left unfulfilled by industry leaders Boeing and Airbus as they concentrated on the 100 plus seat market.

Originally conceived by Hawker Siddeley in the early 1970s as the HS146, the economic downturn put the idea for an 80–100 seat city jet project on hold until the boom years of the 1980s when the idea was resurrected as the BAe 146. The development of this new four-engine jet liner coincided with the Docklands redevelopment programme and by the time the 146 received its type approval London City Airport was up and running.

Critics of the new jet said at the time that operating costs would be too much for an operator to bear when compared to a twin-engine airliner and to a certain extent this is obviously true as four engines need more fuel and maintenance than a twin. However, the performance of the new jet was much improved. It was able to take off in shorter distances, climb faster and fly higher with a better

payload, typically of some 80 plus passengers – a near 100 per cent improvement on the 45-seat Dash 7, and with a much longer range, thus bringing cities like Madrid, Rome, Berlin and Warsaw well within its 1,000-mile range.

Following a successful demonstration test flight of a BAe 146 into London City in 1988, an application to seek a revision of the airport's operating conditions was sought. At the same time, plans were drawn up to extend the runway and parking areas in order to increase safety and efficiency and to introduce a new, dedicated 35-minute river bus service right into the heart of London. When the airport was first granted permission, the introduction of jet aircraft into LCY had been prohibited on noise grounds but these test flights confounded the critics and a survey undertaken of the area found that 83 per cent of local residents supported the idea. Of course this still meant that 17 per cent of residents would still be unhappy, especially those living around Canning Town, but to be fair to the airport management measures were drawn up to mitigate the effects and consultation with the local community still takes place on a regular basis. Richard Gooding, the airport's chief executive at the time of the application, made strenuous efforts to convince the local community that the expansion plans were necessary to safeguard the future of the airport and he hosted a number of meetings whereby he addressed residents and members of Tower Hamlets Council over their concerns.

Three years of detailed planning went by before the then-Secretary of State, Michael Heseltine, finally granted permission for the runway extension and associated works. This meant that the existing runway could now be extended further down towards the end of the central dock. The original turning circle at the eastern end of the runway would now be dispensed with and replaced with the new runway extension, bringing the runway length up from its original 762 meters to its present day length of 1,199 metres. This seemingly rather odd measurement of 1,199

metres does in fact serve a purpose. While 1,200 meters is a nice round figure, a 1,200-metre runway would make it a Category 3 airstrip under the Civil Aviation Authority's regulation CAP148 for airport design. A Category 3 runway also has to have space for a 300-metre width but the central dock on which the new runway was going to be built is only 148 metres wide. By opting for the smaller Category 2 airstrip classification of 1,199 metres by 150 metres, the airport easily meets the Civil Aviation requirements of CAP148. Meanwhile, at the other end of the airport, the ramp area outside the terminal area would also receive an extension by building over part of the wet dock in order to increase the number of aircraft stands that could be made available to airlines.

Also in this part of the airport, and not seen by members of the public today, is the old King George V graving dock. Originally a dry dock whereby ships could be inspected below the waterline, this huge space had to covered over with a giant concrete cap able to take the weight of any aircraft passing over it.

At 245 metres long by 38 metres wide by 13 metres deep, this huge space presented a number of options to the developer. One option was to convert the dock into an airport car park with up to 1,000 spaces being made available. This was an attractive idea at first but it was eventually discounted on the grounds of the risk of explosion from a potential car bomb underneath the ramp area and, more pragmatically, on the high cost of sealing the lock gates from the ingress of water when actual demand for parking at the airport had yet to be determined.

Another option was to just use the dock as a land fill site and top the fill off with a thick concrete cap. On the face of it this would seem to be the easiest option but from an engineering perspective this too had significant flaws. If cheap, low-grade fill was used then there was the risk of subsidence happening at a later date and this would be very costly to rectify and cause massive disruption to the airport's

operations. However, if high-grade fill was used to stabilise the dock then the cost of such fill would be more expensive than what was eventually deemed to be the optimum solution, that being to pump out the dock and build a structural steel framework inside it to support the new concrete cap. When completed, the dock would be flooded again in order to provide structural balance and integrity.

It was this last option that was adopted by Mowlem and so far it has proved to be the right one but with a forecast shelf life of some 30 years with allowances being made for degradation of the uncoated steel structure, this area of the airport will inevitable have to undergo some remedial works in or around 2020–22. How this will affect the operations of the airport remains to be seen but if it follows previous works practice at the airport then passengers will hardly notice as the runway extension and all the works associated with it were accomplished without closing the airport, something which no other airport has ever been able to manage.

While the airside of the airport has undergone some significant changes in the last 25 years, the terminal side of the operations have not been forgotten. The original very small passenger terminal underwent a radical makeover in 1997 when the international and domestic lounges were amalgamated and new retail outlets incorporated into it. This took the best part of a year to complete and was opened by Nick Raynsford MP the following April. Two years later, the airport's administrators moved out to new premises at City Aviation House, which enabled the Meridian Business Centre to be completely refurbished. The following year a further programme of redevelopment took place when the passenger restaurants were upgraded and improved and in 2001 the new arrivals hall was completed, which allowed passengers to claim their bags within a hardly believable target time of just ten minutes. Sadly, all of these improvements failed to save the airport's riverboat service, which was withdrawn in 1993.

No more terminal upgrades were planned after this but Desmond took the airport's business a stage further when he opened the new Jet Centre. This would bring corporate aviation right into the heart of London for the first time, for previously executive jets like the Falcon were usually directed into Biggin Hill. The popularity of the Jet Centre has grown to such an extent that their operations have expanded into the west of London at RAF Northolt.

After Dermot Desmond sold his interest in LCY the new owners took stock before embarking on a further programme of long term improvements to the airport. A major scheme to redesign and configure the airport's upper floor, where the departure lounge was located, was drawn up and carried out in two distinct phases. Phase 1 was completed by May 2008 which not only brought in a new retail shopping area but increased the seating capacity in the lounge by a further 250 seats. At the same time they introduced a large number of high speed internet connection points where passengers could use their laptops while overlooking the apron. Complimentary Wi-Fi was of course available throughout the terminal. Phase 2 of the scheme was completed less than a year later and was clearly aimed at the business traveller who now expects to be able combine luxury and relaxation with all the modern business aids there are for instant communication. It brought the total investment into this project to some £41.5m, which is almost as much as the whole airport cost to build 25 years ago.

Today the airport now has twenty-four gates and is virtually unrecognisable from the original design for the STOL port. While it will never compete on equal terms with London's other airports it has managed to carve itself a unique position in the airport market.

Given the fact that the majority of its customers are business travellers, the airport has expanded its route network to include some of the more popular holiday destinations like Majorca, Minorca, Ibiza and Venice. Although it will

never be in the same league as its bigger corporate brother at Gatwick, which handles thousands of holiday flights per year, the inclusion of these destinations at LCY has subtly changed the way the airport operates. The airport lounges still cater primarily for the business traveller but there is now a greater retail presence there and the baggage halls now have carousels as more hold luggage tends to be carried. However, these are still tiny compared to the huge and complex baggage systems installed at Gatwick or Heathrow.

Unlike other airports, upon arrival at LCY the passenger is presented with ... well, not a lot really. The centre of the concourse is dominated by two rows of self-service check-in machines and beyond those is the escalator to the departure level. On the right hand side are the check-in desks for those with hold baggage to check in while on the left you have the usual array of the Information desk, a currency exchange, British Airways and the ubiquitous WH Smith - a shop that has been associated with virtually every UK airport since Croydon opened in the 1930s. Beyond are two areas where food and drink can be purchased but other than these the rest of the airport's facilities are located upstairs in the departure areas.

What was once an open area above the check-in machines has long since been covered over and turned into a first-floor departure lounge. This is also where security screening takes place, the retail/shopping space and where the food outlets are.

Today there are fifty-six routes flown by eleven different airlines. The route network is very different from when the airport was first envisaged. The London to Paris route is of course one of the best served, with flights into both Charles De Gualle and Orly airports. The number of regional airports served by LCY has also improved with regular services to Manchester, Edinburgh and Dublin. All of the main European business centres are served, with additional routes flown to tax havens like Jersey, the Isle of Man and Nice – handy for Monaco. However, perhaps the most

important route development has been the introduction of the British Airways service to New York's JFK airport.

With the demise of Concorde, sometimes known as the Businessman's Express, British Airways took a giant leap of faith in London City by inaugurating a dedicated twice daily service to New York. Now, instead of heading out to Heathrow the city gents can opt for the much shorter ride on the DLR to LCY and fly on two specially fitted out Airbus A318s. Not being supersonic, the A318 offers a much slower trip but the level of comfort more than makes up for it. Concorde may well have been luxurious but big inside it was not. With only 32 seats on board compared to Concorde's 100, there is plenty of space on board. Each seat converts to a bed and as you would expect, it has all the electronic toys and connections a businessman needs today. The menus are equally grand, if not quite in Concorde's league, but BA obviously think this is now their most prestigious flight as they grant it the call sign BA001, an accolade previously given to Concorde. However, this flight's biggest attraction is that upon arrival in New York you can sweep straight through the terminal as you will have already cleared US Customs and Immigration in Shannon. Shannon? But that's in Ireland isn't it? Well, yes it is and that is perhaps the one surprising thing about this service. The A318 doesn't have the range to cross the Atlantic east to west and so a quick stop to refuel takes place while at the same time passengers are cleared through US Customs. This in itself is probably enough to make the service attractive as even a first class ticket cuts very little ice with US border control these days.

It's doubtful if any of the airport's founders ever expected such a widespread route network to be developed at LCY. The introduction of new types of aircraft like the 100-seat Embraer 180 has enabled these services to be developed and they are rapidly replacing the now ageing Avro RJ/ BAe 146 fleets. With innovative services like this being introduced, the future of London City Airport is looking very good indeed.

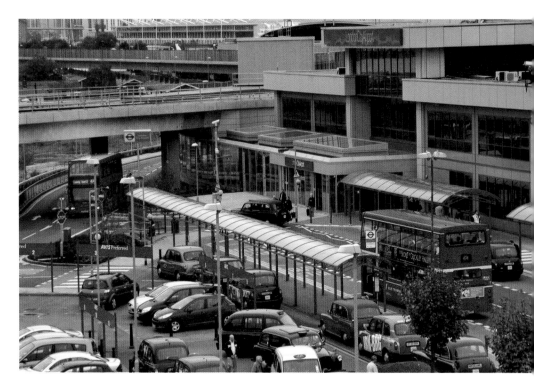

This view of the forecourt at London City shows clearly how busy the airport now is.

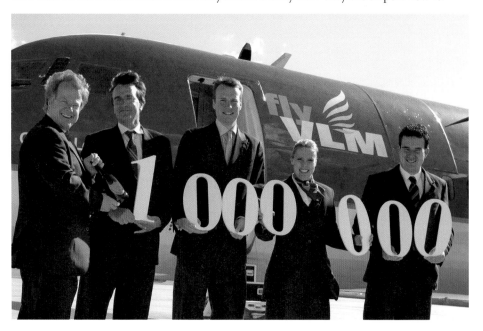

The airport's one millionth passenger flew with VLM to Rotterdam.

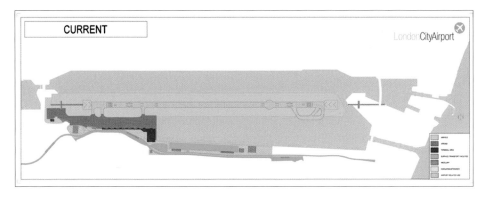

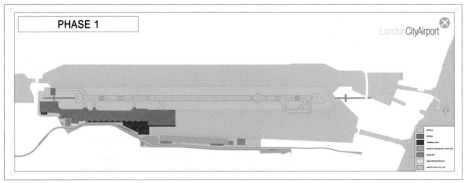

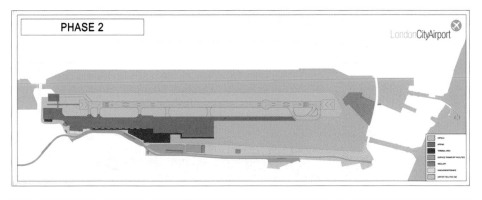

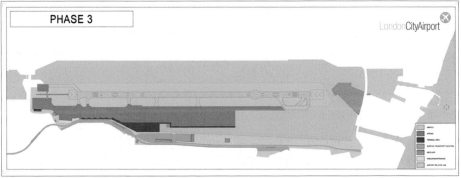

A series of diagrams showing the expansion of London City Airport over the years.

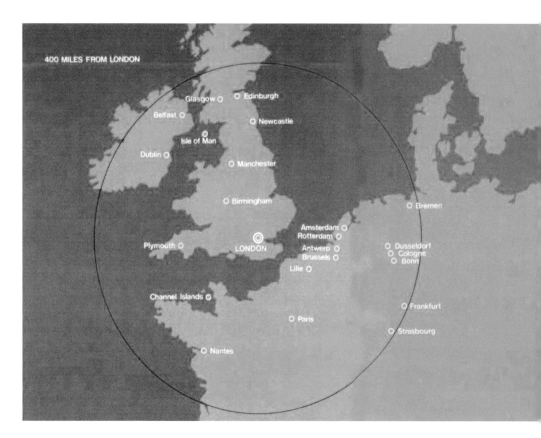

Glasgow O O Edinburgh
Belfast O O Newcastle
 O
 Isle of Man
Dublin O
 O Manchester

 O Birmingham O Bremen

 Amsterdam O
 Rotterdam O
Plymouth O LONDON Antwerp O O Dusseldorf
 Brussels O O Cologne
 Lille O O Bonn

Channel Islands O O Frankfurt

 O Paris O Strasbourg

 O Nantes

A map taken from the original Mowlem Construction brochure predicting the destinations which STOL aircraft would be able to reach from London.

The old airport lounge.

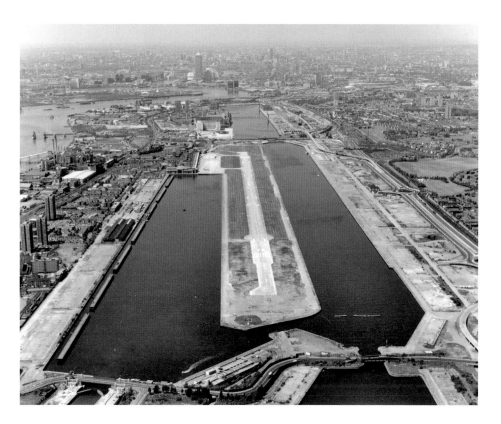

The first extension to the runway towards the east from the old turning circle.

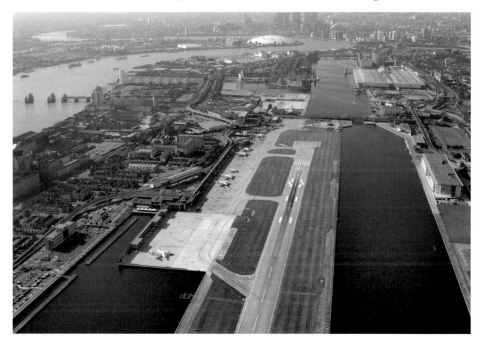

The extension to the airport's apron over the wet dock can be clearly seen in this image.

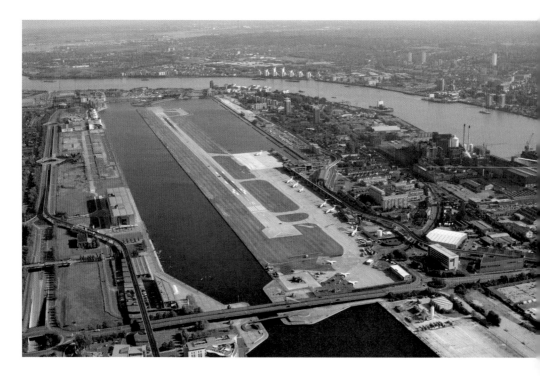

Looking east over the airport.

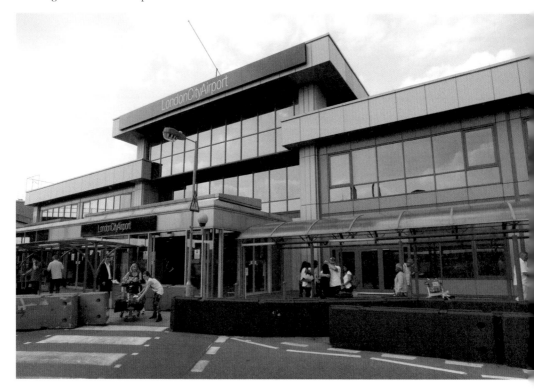

The airport entrance today.

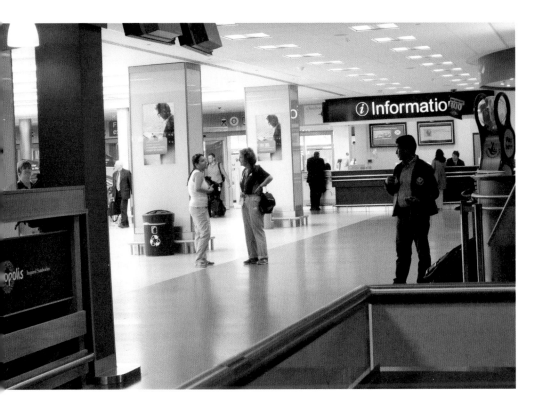

The entrance foyer.

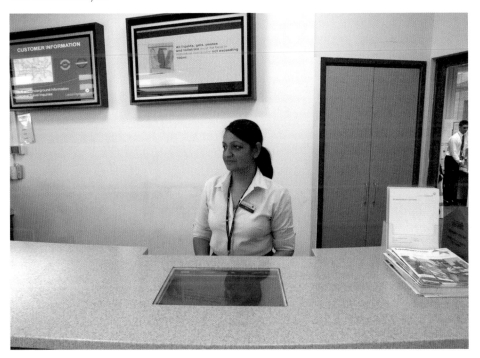

Pam, one of the airport's friendly information receptionists.

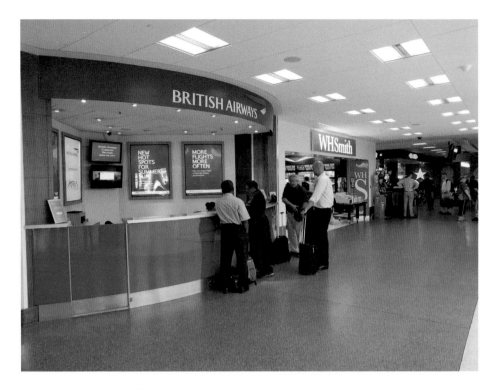

The British Airways desk.

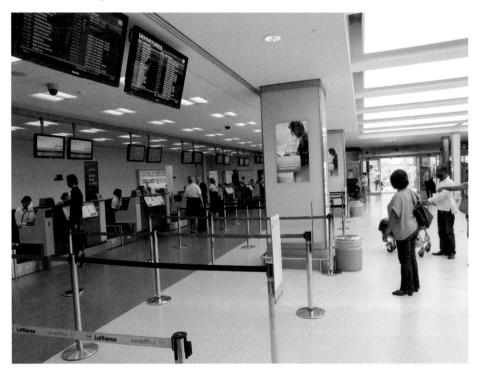

The check-in desks at London City.

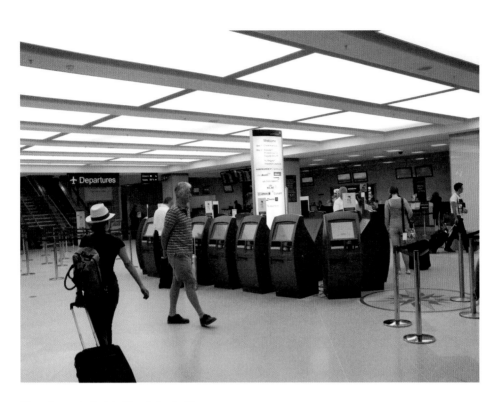

The airport's Quick Check-In facility.

This way to Departures.

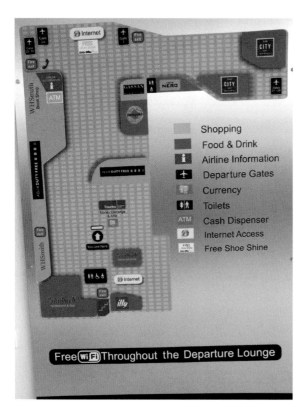

A floorplan of the airport.

The new airport lounge.

Gassan jewellers, one of the many fine retail opportunities at London City Airport.

Making time for a quick snack: one of several refreshment areas at LCY.

Two more views of the revamped upper floor retail area.

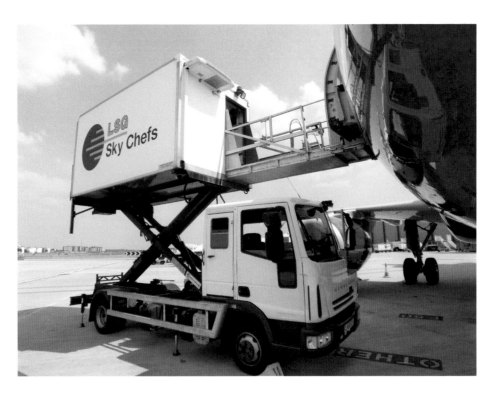

Sky Chef food service delivery.

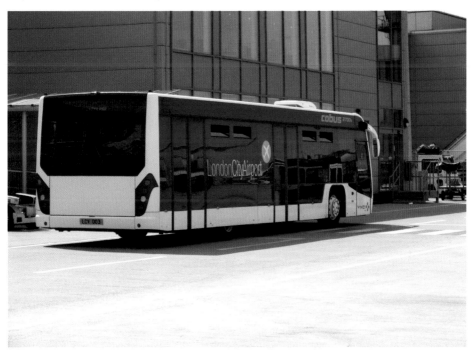

Unlike other airports, just one airport bus is required for the whole airport to transfer passengers to the aircraft.

Despite the expansion, London City is still small enough to have to use airstairs instead of airbridges for access to aircraft.

A warm 'Welcome Aboard' from a BA hostess.

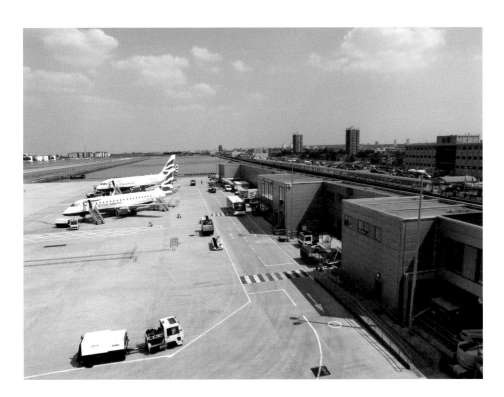

The east apron and the extended pasenger terminal gates.

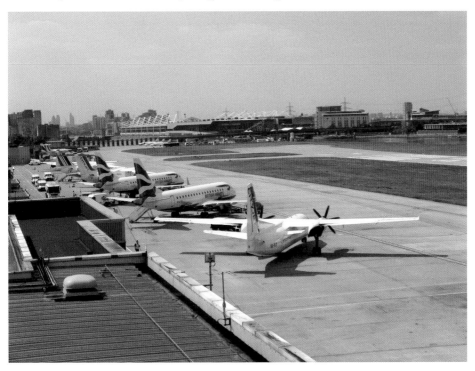

The view of the west apron from the control tower.

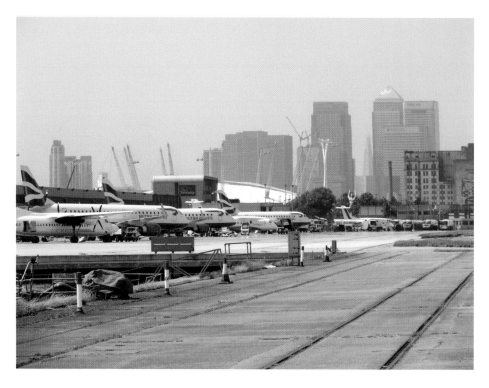

Looking west towards the skyline of Canary Wharf.

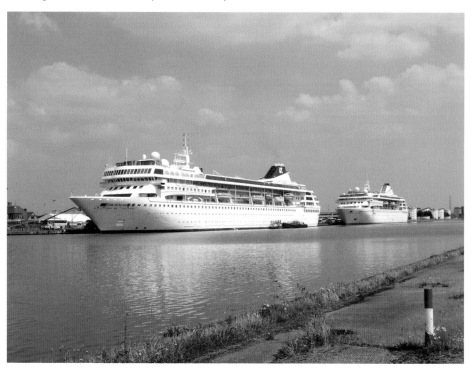

Cruise ships moored in the Albert Dock.

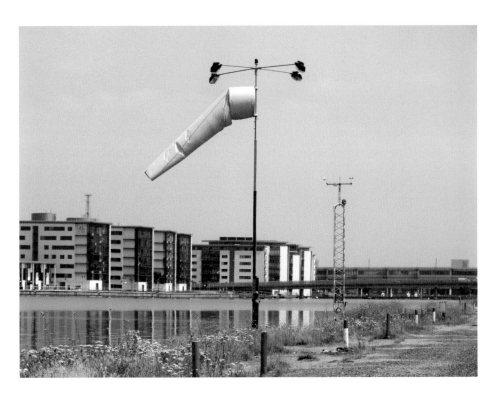

Old technology, maybe, but still reliable: the airport's windsock.

Two members of the airport's Operation team, Joseph Hatch and Ben Harrison.

Johanne Enriquez, one of the Airport Ops control room staff.

Steve Fair, the Senior Ops Room Controller.

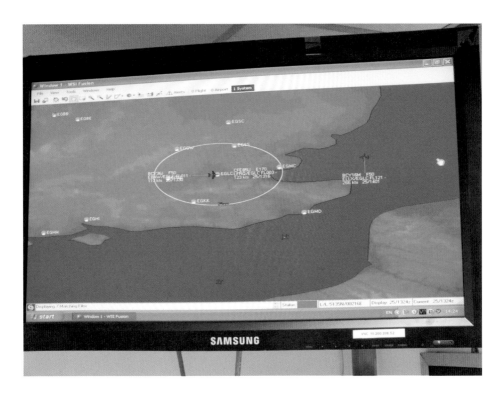

A monitor showing the London City air traffic control area.

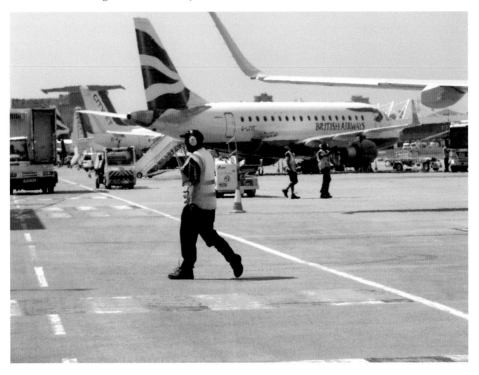

A busy day on the ramp.

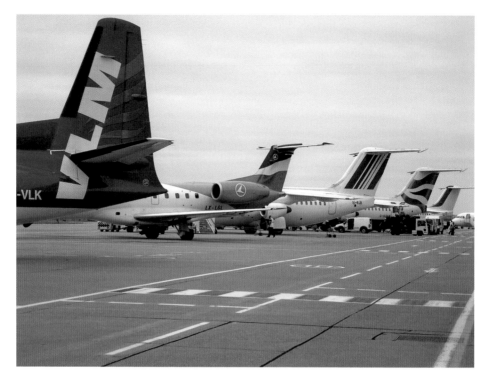

Some examples of the colourful tail art now to be seen at London City Airport.

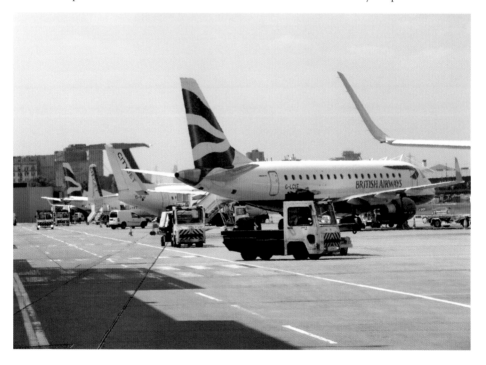

BA and Cityjet aircraft on the ramp.

Rear view of a BA Embraer 190.

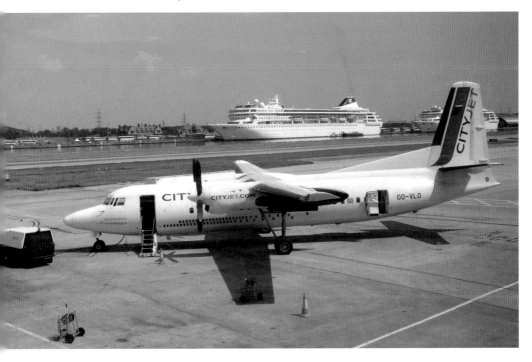

A Fokker F50 of Cityjet on the ramp.

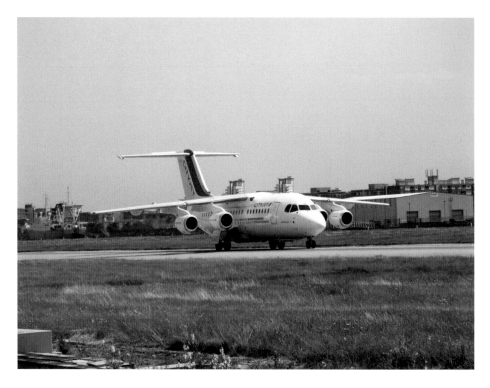

The BAE 146 was one of the new generation of STOL jets to use London City Airport. This example, belonging to Cityjet, is seen taxiing in after landing.

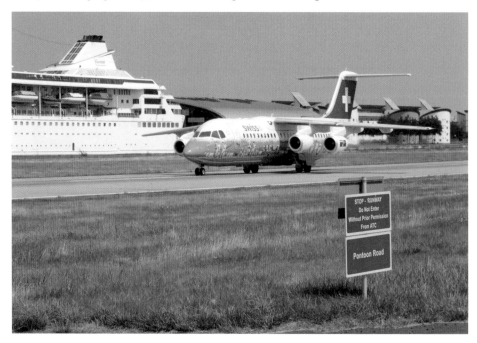

Another BAE 146, this time belonging to Swiss Air, is seen back tracking down the runway after landing at the airport.

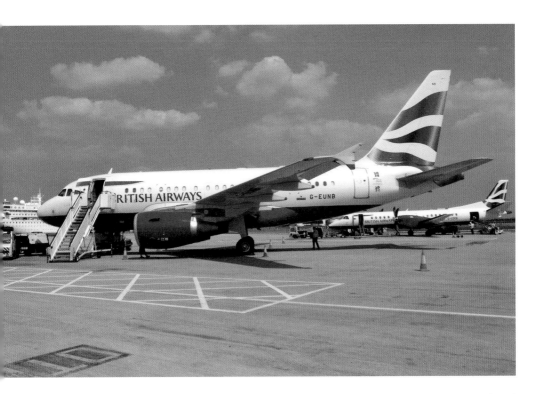

One of the specially equipped British Airways A318 business jets is seen here on the ramp (above) and taxiing out to the runway (below).

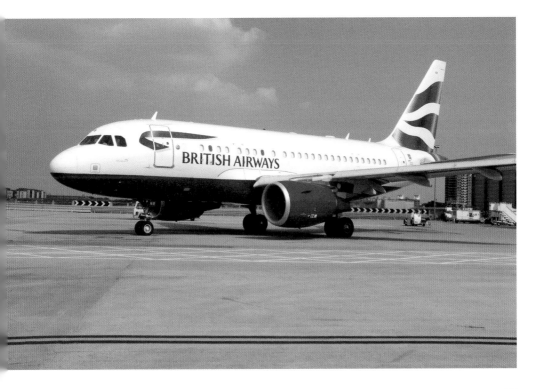

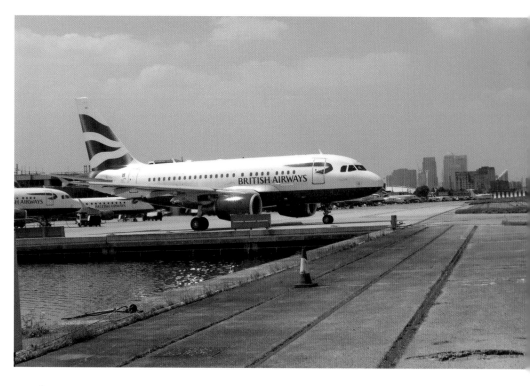

British Airways now operates these A318s between London City and New York and the airline feels this is their most prestigious service – it uses the same callsign as Concorde, BA001.

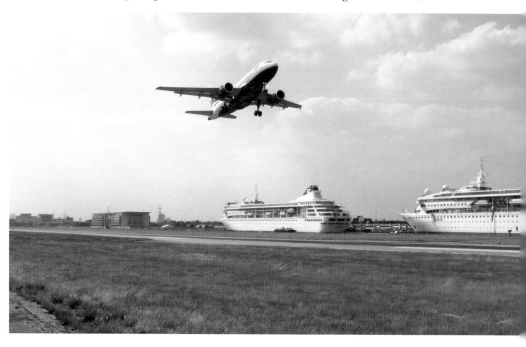

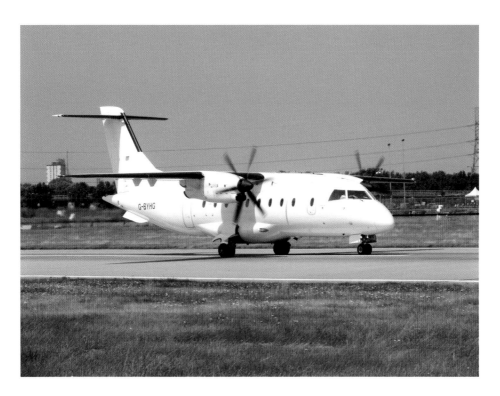

A Dornier 328 of Scot Airways taxiing at the airport.

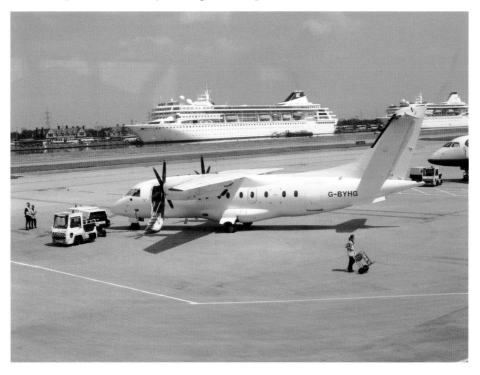

Scot Airways' Dornier 328 on the ramp.

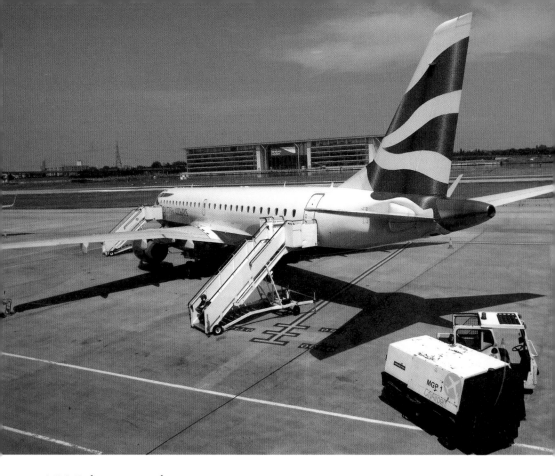

A BA Embraer 190 on the ramp.

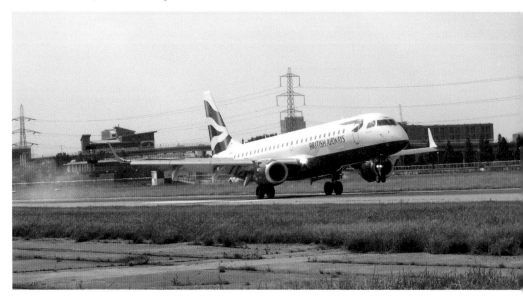

An Embraer comes in to land.

Sold!

While £50m might not sound like a lot in today's world of million-pound bonuses for bankers, twenty-five years ago it was obviously still a lot of money, even to a highly profitable company like Mowlem. Since the airport opened passenger numbers had grown steadily to a peak of 230,000 per year but the first Gulf War of 1990/91 saw passenger drop significantly. Passenger numbers eventually returned to former levels by 1993 and did in fact increase over the next three years but with little or no experience of operating an airport coupled with restrictions on the type of aircraft they could operate together with a relatively short runway, the directors of Mowlem decided it was time to sell their stake in the airport to another operator.

To the outsider, the British Airports Authority (BAA) would have seemed to be a logical choice of operator as they already owned and ran three of London's airports, Heathrow, Gatwick and Stansted, London Luton of course being under the control of the Local Authority. However, under Mrs Thatcher's plans for privatisation the BAA was no longer a government body and competition rules would have been severely stretched if the BAA were to be given control of yet another airport in the south-east. Having said that, there is no evidence that BAA actually wanted to buy and operate LCY as it would be difficult to fit in with their existing operations at what are much larger airports.

So if not BAA, then who? At the time there were some other big players in the global airport market with an interest in UK aviation but none of them seemed interested in acquiring an airport with such severe limits on its operations. Of these, TBI, Peel Holdings and the Manchester Airport Group could have been front runners to head up the operation but in the end it was a surprise purchase by the Irish entrepreneur and financier Dermot Desmond, who took over the airport in late 1995 for the bargain price of £23.5m.

A self-made billionaire, Desmond was not your usual City type. Sometimes known as 'The Kaiser' for his very distinctive handlebar mustache, he would not have looked out of place flying a Spitfire! He was though, and indeed still is, a very shrewd businessman and under his stewardship the airport continued to grow and prosper. His arrival at the airport coincided with several changes in the airport's management and some changes in air transport in general.

At the time of his takeover nine airlines were regular users of the airport, offering flights to twelve different European city destinations. Passenger numbers had also surpassed the half million mark for the first time, which was more than double the original estimates for the airport when it was first mooted. Also at this time, ticketless travel was introduced into the UK. While this was a great aid to cutting down queues at the UK's major airports, for an operation like London City it helped to boost its popularity as check-in times – which were already measured in minutes rather than hours – could be cut even further. To the business community this was an added bonus and a reflection of how far IT systems had become a key part of the aviation system as a whole.

Under Desmond's leadership, a new management team was put in place. The first of these was the appointment of Roy MacSharry as chairman, followed a short time later by Richard Gooding as the new managing director of the airport. It would be Gooding who would oversee the next phase of the airport's development and within two years the terminal's departure lounge was redesigned to incorporate international and domestic departures and a new retail outlet. The success of these and other projects was reflected in tremendous passenger growth and more than 1 million passengers were now using the airport each year.

By far one of the biggest improvements to the airport under Dermot's watch took place not in the terminal but on

the runway. Having already extended the airport's runway, the addition of a holding point at the eastern end of the runway meant that two or maybe even three aircraft could now taxi down the runway together to be ready to take off on runway 28. Although this hasn't stopped aircraft from back tracking down the runway after landing on runway 09, it did give the airport a greater measure of efficiency. This simple addition to the airport layout increased its operational capability substantially and without a doubt it was a major factor in increasing the airport's profitability.

Another new owner; Global infrastructure Partners

In 2006, Desmond showed he had made a shrewd investment when he sold London City Airport for a reported £750 million to a consortium made up of US insurer AIG (American International Group), GE Capital and Credit Suisse, the last two investors forming the two halves of GiP (Global Infrastructure Partners). It is not exactly clear why Desmond decided to sell his interest in the airport but having done so and made a very healthy profit in the process, he rewarded his loyal staff with a very welcome bonus. It is now very clear that Desmond had transformed what was considered by many to be a 'white elephant' into what had been voted one of the best airports in the country. When Desmond first bought the airport, his investment was thought to be rather unsound move on his part and the talk in City was that he was taking a very large risk at a very uncertain time. This was partly because London was going through another recession with even the Reichmann Brothers' flagship Canary Wharf development, one of the original 'stars' of the London Docklands Development Commission, being taken into receivership.

GiP have since become a major player in the UK airport industry and have recently taken over control of Gatwick and Edinburgh airport from BAA but at the time of the takeover in November 2008, LCY was their first such acquisition. Joseph Cassano, president of AIG-FP, said

at the time: 'I am extremely pleased that AIG financial Products and global infrastructure Partners have been successful in their bid for London City airport. The airport has tremendous potential.'

Since making its initial investment in London City Airport, GIP has maintained a program of investment and operational improvements aimed at increasing capacity and improving the airport's operating efficiency and service quality. From October 2008 it increased its stake in the airport by acquiring 50 per cent of its partner's shareholding, thus taking its total stake in the airport to 75 per cent.

GIP are obviously well pleased with their investment as they continue to support a long term policy and programme of improvements to the airport. In 2006 the airport published its new Master Planning document, which went out to public consultation soon afterwards.

Finally, in 2008 AIG decided to sell their remaining 25 per cent stake in the airport and their holding was eventually purchased by Highstar Capital in September of that year. Meanwhile, both GIP and HighStar Capital take an active interest in the day-to-day management of the airport with two seats allocated to each company on the Board of Directors.

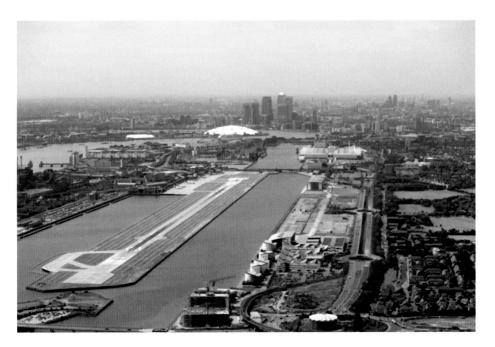

The new runway, now with the added holding point.

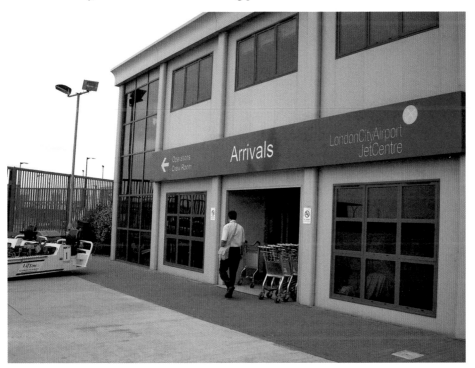

The Jet Centre.

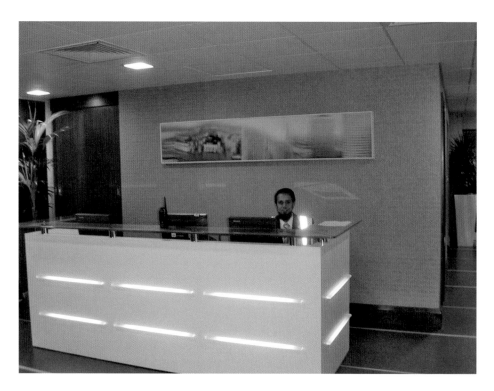

The Jet Centre check-in.

The Jet Centre lounge.

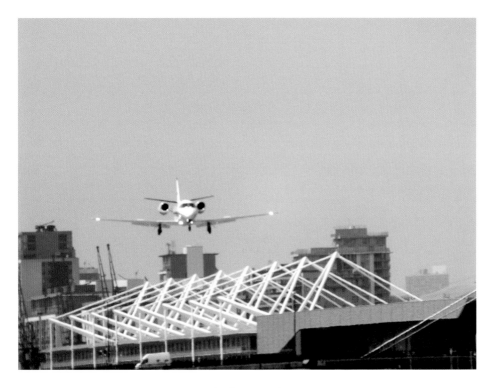

A Cessna Citation executive jet on its final approach to LCY.

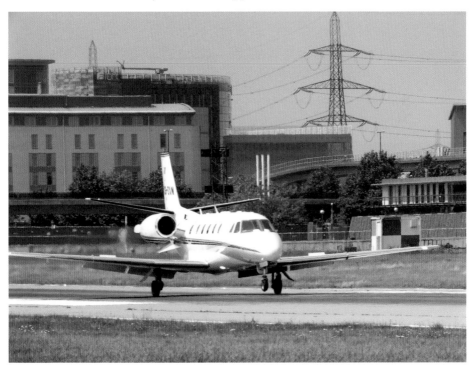

Followed by a successful touchdown.

Cessna Citation C56 taxiing in.

Executive jets waiting at the Jet Centre.

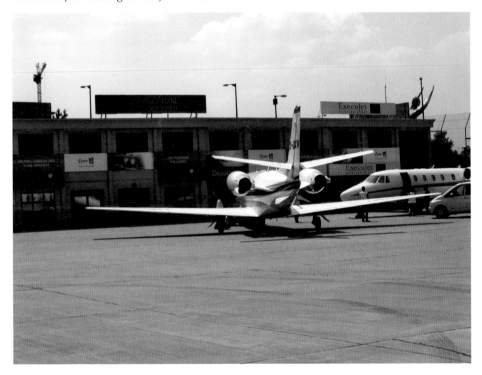

The Jet Centre from airside.

The DLR Connection

When the airport was first mooted, it was always envisaged that it would be connected to the City by Docklands Light Railway, the DLR, but like so many other things that were promised in Docklands at the time, it didn't happen right away. This in itself is not surprising as in such a big, multi-faceted project there were always going to be things that wouldn't go according to plan. In the case of the DLR it wasn't the lack of will that prevented the building of the railway but the amount of money that had been set aside for it. As a result, the DLR was sometimes referred to as not being a proper railway. To a certain extent this rather critical view of the DLR was correct as it is classed as a *light* railway but its image certainly wasn't helped by the fact that when it opened it only had seven railcar units on it! As someone said at the time, with the budget they had, just £77m, they got the sort of railway that money could buy rather than sort of railway the project really needed.

Having said that, the design of the DLR was a radical step change in Britain as it featured automatic, driverless trains. This was not only technically difficult to achieve at the time given the amount of automation that would be required but there was also pressure from the Transport Unions, who objected to the overall concept. They reasoned that if driverless trains could work there then maybe they could be introduced elsewhere on the rail network. This is an idea which has never really gone away as 25 years later there are some controversial proposals still being put forward by TfL for introducing driverless trains on the London Underground network.

Eventually, the problem with the unions was resolved and a track route plan was drawn up. Originally starting from Tower Gateway station on the edge of the City, it took in some of the former routes of the old Great Eastern line and the London & Blackwall Railway while other parts of the route were to be brand new. Once again Mowlem was to play a part in the construction of the new railway along with GEC,

who masterminded the electronics. The first stage of the DLR opened on 31 August 1987 and proved to be very popular with commuters to Canary Wharf. However, there was never enough money to build the complete network and while the new business district around Heron Quays and the City was now connected, the airport had to wait until 2 December 2005 to be connected into the rest of the DLR network. Since then the DLR has undergone further improvements and extensions and now has some 20 miles of track and ninety-four trains running on it, some of which were built by aerospace company and train maker Bombardier.

Without a doubt the opening of the DLR station at the airport helped to transform London City's fortunes. Although there had been a dedicated Airport bus link into and from the City, it was never that popular with the business community, who found going on a bus to be a bit downmarket. When coupled with the limited amount of car parking available at the airport, passengers tended to rely on taxis. However, this too was not without its problems as the major redesign of the network of roads in and around Canary Wharf sometimes caused even the most knowledgeable London cabbie to get lost on their way to the airport – as the author once found to his own cost!

The planning and construction of the Docklands Light Railway highlights a problem that has dogged several other UK airports, which is one of connectivity. For an airport to work effectively, it has to be able to access its market, that is to say all those people who could fly from there and all of those people who want to access that particular location or area. This is something which an airport like Manston in Kent, often promoted by its owners as an airport that serves London, can never really deliver. They are simply located too far away from their potential customers and in Manston's case it is over 60 miles away from the capital with no direct road or rail links.

By a happy coincidence, the owners of London City also own Gatwick Airport, which today is served directly by the Gatwick Express. In purchasing Gatwick from the BAA, the new owners

inherited an airport that was the first in the world to integrate a rail link into the overall design of the airport terminal.

Having first opened in 1936 as a private venture to rival the Government's own airport at Croydon, several lessons should have been learned from this enterprise but for decades our politicians and airport operators chose to ignore the advantages of including a rail link to our major airports. This failing on the part of our transport planners was most apparent at Heathrow, which for years saw passengers using public transport having to take a bus or taxi from the Underground station at Hounslow West to complete their journey to the airport. This was a completely unsatisfactory state of affairs which wasn't rectified until the Piccadilly Line was extended in December 1977, more than 30 years after Heathrow first opened!

As we have seen, the DLR nearly suffered a similar experience by not being connected to either the new commercial centre being developed at Canary Wharf or, perhaps more importantly, to the City at Bank. Fortunately for the airport and its customers, the folly of Heathrow was not to be repeated and the DLR link to the airport was always envisaged as a vital part of the scheme. However, the economic recession of the 1980s unfortunately delayed its construction but the missing link to the airport was built as soon as funds became available. Without a doubt, the DLR is a key part of London's infrastructure and its contribution to the economic well being of the City of London should not be underestimated.

The opening of the new DLR station had an immediate impact on the fortunes of the airport, for in less than twelve months of the station being opened it had alreadybeen awarded the Community Rail Award for best 'Local Transport Integration Project'. More importantly, with a direct train now running every 8–15 minutes, the journey into the City at Bank Station could now be done in just 22 minutes. Today the DLR carries some 100,000 passengers per day but is capable of carrying over 300,000. It has now recorded over 75 million passenger journeys since it first opened. Not a bad effort for a *Light* Railway and not even a *Proper* railway at that!

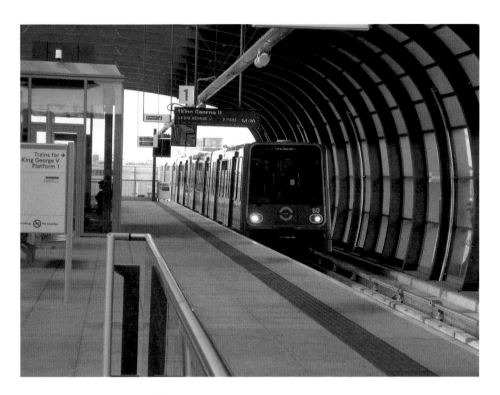

A DLR train arrives at London City Station.

And disgorges its passengers right into the airport.

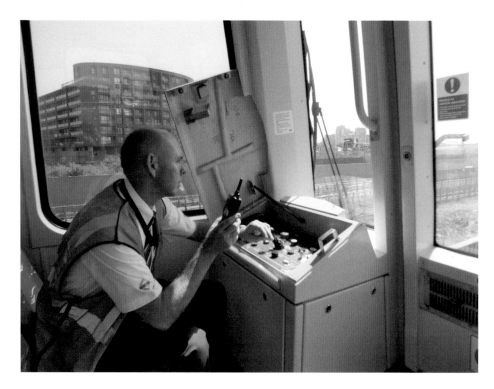

A rare sight: a DLR driver at the controls.

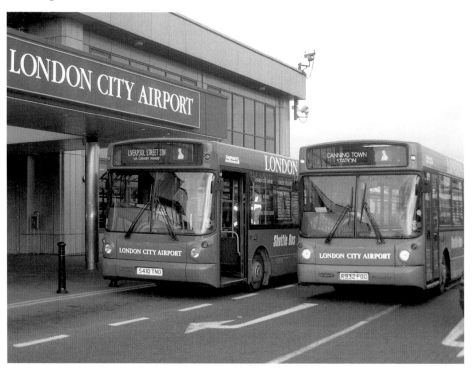

The shuttlebuses used at London City before the DLR arrived.

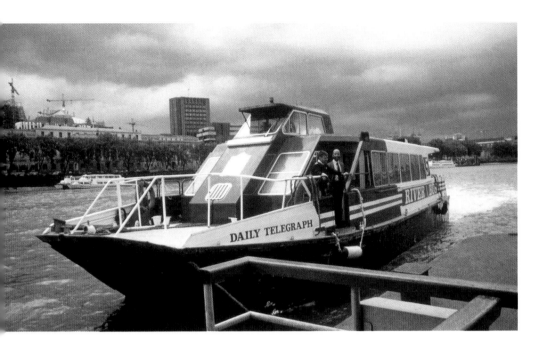

The ill-fated airport river bus service – sadly discontinued in 1993.

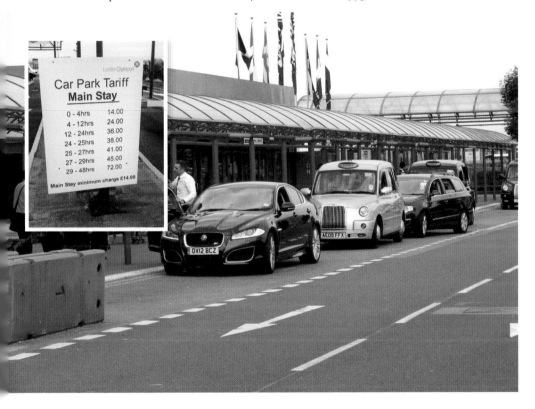

Car Park Tariff
Main Stay

0 - 4hrs	14.00
4 - 12hrs	24.00
12 - 24hrs	36.00
24 - 25hrs	38.00
25 - 27hrs	41.00
27 - 29hrs	45.00
29 - 48hrs	72.00

Main Stay minimum charge £14.00

Taxi and drop-off point.
Inset: The car park tariff.

Safety & Security at the Airport

While LCY might be a small airport, its attitude toward safety is no less than that offered at the biggest. Just like its much bigger brother at Gatwick, LCY still has its complement of Safety Officers, Fire & Crash Tenders and a practice fire training simulator located well away from the terminal buildings. However, LCY can boast some extra items of equipment that no other UK airport can, not even Heathrow, as they have not one but *three* emergency rescue boats!

Being virtually surrounded by water, the rescue boats are vital pieces of equipment. Should an aircraft ever have the misfortune to slide sideways off the runway into the dark, cold and unforgiving water of the docks then passengers – and no doubt the crew – will be relieved to know that help will be on hand in a matter of seconds rather than having to wait to call out a lifeboat from the RNLI.

Fortunately, in all the years the airport has been operating the services of the rescue boats have never been called upon and the safety record of the airport is almost without blemish. A search of the official safety records for LCY does in fact show up only three instances whereby incidents were reported and needed to be investigated. The first of these occurred on 18 November 1996 when a BAe 146 landed rather too hard on its nose wheel and without brakes and spoilers. No one was hurt and no damage was recorded but the crash tender was placed on alert in case of a fire – which fortunately there wasn't.

The second incident happened just under a year later on 15 September 1997 when another BAe 146 overran the runway threshold. This too can be seen as a relatively minor incident and is probably the motoring equivalent of driving over the white STOP line at a road junction – but as T junctions are quite rare on runways it's not something any future passengers should really worry about.

The final incident took place on 13 February 2009, when an Avro RJ-100 suffered a collapsed nose wheel

upon landing. This time there was a slightly more serious outcome as four minor injuries were reported on board but thankfully nothing too serious.

The air-minded among you might by now have spotted a link between all three incidents in that the types of aircraft involved were virtually the same, the Avro RJ and the BAe 146 being almost identical. However, to make any assumption that this type of aircraft has a safety problem by operating at LCY would be very, very wrong. Having flown in both types of aircraft many times from a number of different airports, including LCY, the author has every confidence in the type and actually prefers them to some of the much larger aircraft types that are in currently service.

The three incidents described here all warranted investigation by the CAA and the diligence shown by the aviation authorities reflects not only the airport's but the UK's uncompromising attitude towards passenger air safety. Nothing is allowed to endanger an aircraft operating from LCY, as the author witnessed during a recent visit there. Dedicated patrols scare off any potential bird strikes and the officers concerned are empowered to close the runway at a moment's notice should a flock of seagulls or crows decide to take a closer look at the 'metal birds' that fly from there.

More recently, LCY has helped prevent accidents by virtue of its very existence. On two separate occasions, helicopters – which are forbidden from operating from LCY – had to make emergency landings there. An Army Chinook helicopter suffered a bird strike while crossing London and put down at the airport in order to inspect any damage done to the rotors before being allowed to proceed onwards. Later on, a police helicopter also showed signs of an engine malfunction and landed there but this turned out to be nothing more than a faulty warning light. Neither incident caused any problems for the airport but had these turned out to be more serious then help was at hand to deal with them in the shape of the airport's four fire tenders.

When compared to the other London airports, City Airport easily comes out on top in terms of air side safety but it's worth mentioning two other incidents that took place *outside* the airport. The first incident took place on 22 April 1991 when two trains on the DLR collided, which resulted in the shutdown of the whole DLR system while investigations were carried out. At first it was thought that the driverless trains were at fault but this was soon found not to be the case. It did, however, create some major problems for the airport as passengers were either stranded on the DLR or couldn't get to the airport in time for their flights.

The second incident, which would have much more dramatic consequences for the whole of the aviation security sector, happened on 9 February 1996 when a bomb planted by the Provisional IRA blew up a bridge on the DLR at South Quay. Although the bomb was not aimed at the airport itself, it marked a major change in airport security across the country.

Following this incident, the infamous attacks of 9/11 and the London bombings of 7/7, security at the airport has quite rightly been stepped up and is a much more high profile affair. The 9/11 attacks in particular placed the airport on a very high alert in case a copy cat attack on the Canary Wharf tower was attempted; this was considered to be a very real possibility at the time and in fact the airport closed down operations for two days while security was reviewed.

Despite the extra security measures that are now in place as a direct result of these attacks, LCY still enjoys a very good reputation for processing its passengers quickly and efficiently. In 2010 two extra security checking lanes were added to the four lanes that were already in operation in order to deal with any queues that may occur and to speed up the search process. Meanwhile, Heathrow continues to suffer bad headlines for the long delays travellers can experience when passing through Security, Customs and

Immigration, and yet LCY doesn't even warrant a footnote in the press! This is in part due the nature of the airport, the capacity of the aircraft used there and its admittedly limited range of destinations; but even so it is a remarkable achievement and one which the airport can be really proud of.

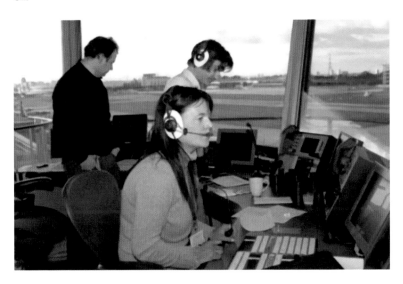

Air traffic control at work.

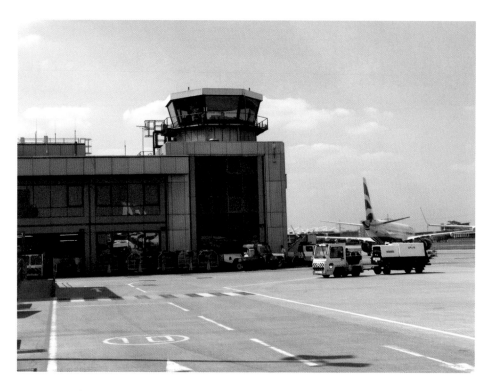

Two external views of the airport's air traffic control tower.

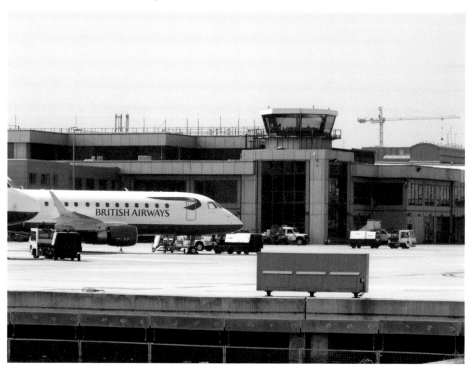

Ben Harrison, one of the airport's safety operational controllers, is seen here on a patrol of the runway.

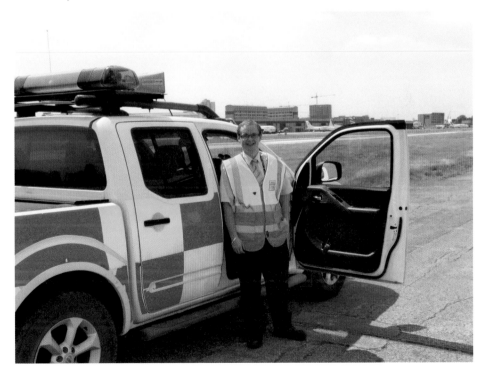

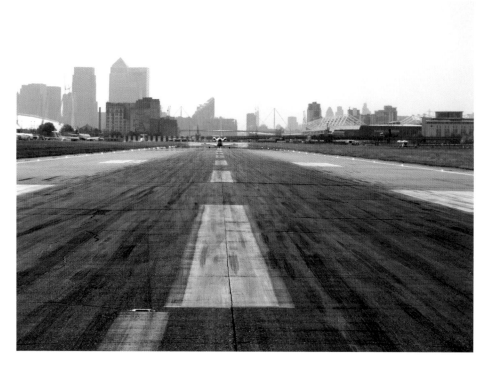

Following a jet in for a runway inspection.

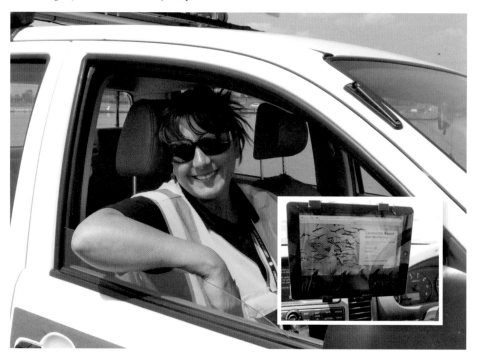

Johanne Enriquez on one of the regular bird-scaring patrols.
 Inset: Bird scare data logger.

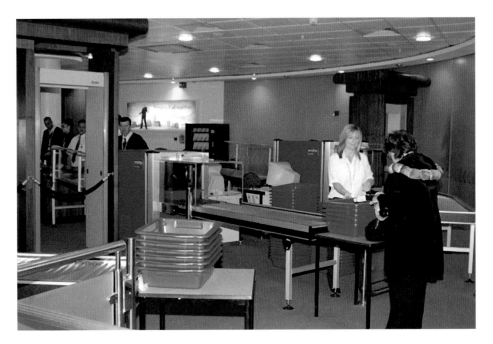

Security checks in the early days of the airport.

Luggage security screening at the airport today.

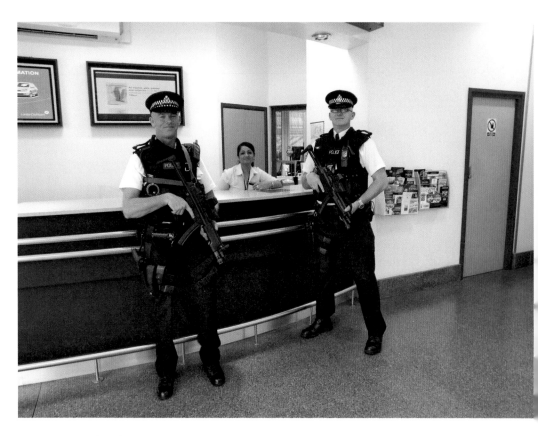

PC Townshend and PC 'Mushy' Pease of Police Airport Security.

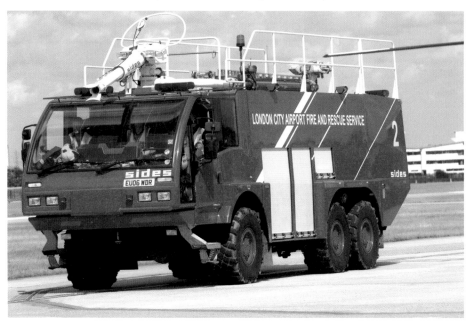

One of the airport's four fire tenders.

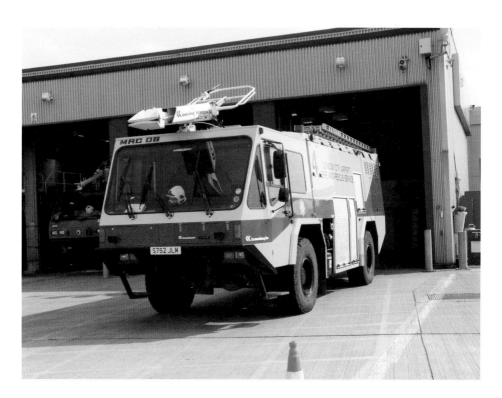

One of the four fire tenders used by the airport outside its fire station.

The airport's fire training rig.

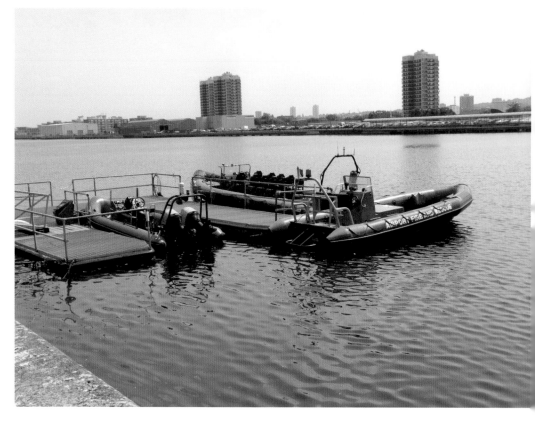

The airport has three emergency rescue boats on standby.

A British Airways RJ-100 suffered a collapsed nose wheel on landing at London City. Four minor injuries were reported aboard, but thankfully there was nothing more serious.

Snow!

In December 2010 a weather system descended upon the British Isles and blanketed it in snow, causing virtually the whole of the UK airport system to grind to a halt. It was, according to official reports, the coldest December since records began. The worst affected airport was Heathrow, which closed down for three days and created chaos for travellers as far away as Australia. The failure of BAA to cope with the problem in the run up to Christmas, one of the busiest times of the year, gave the press a field day and many questions were raised in the House of Commons as to why the UK's response to the weather was so bad.

London City fared better than most as the snow clearance teams swung into action to keep the runways clear but even so, travel patterns were disrupted as the author found to his own cost, being unable to catch his flight to Amsterdam on that first day of the bad weather.

The biggest problem facing LCY that day was not the amount of snow falling on its runway, which at the time was quite minimal at about 5 cm, but the disruption to the airport's schedule caused by heavy snow elsewhere. On that first day of the snow storm, aircraft were still able to land and take off from the airport but heavy snow and runway closures at other airports meant that incoming flights were being cancelled in droves.

From the vantage point of the new upstairs departure lounge passengers could see the runway sweepers plying backwards and forwards to clear snow off the runways and the apron in front of the terminal. To the casual observer that evening it must have looked like a thankless task but the three drivers worked as a team and to a predetermined clearing pattern. Acting rather like minesweepers in the Navy, the second and third snow ploughs followed their leader down the runway, their angled revolving steel brushes clearing the snow to one side as they went.

The accumulation of snow causes any airport a problem and LCY is no different in that respect. Having cleared the runways, snow is dumped onto a designated area or aircraft stand to await controlled disposal later on. Someone once suggested that they should just push the snow into the waters of the dock but as the runways are sprayed with de icing fluid, any snow has to be treated for contaminants.

Meanwhile, the various electronic displays in the terminal were showing that more and more flights were being delayed or cancelled. One of the members of staff coping with the growing number of passengers that were now filling the airport was Paul Millar, a member of the ground staff team for British Airways. Paul took some time out from his duties to inform me about what was going on behind the scenes to keep the airport functioning. It seemed that flights into and out of Europe were being affected over a much wider area. Consequently, there wasn't much hope of getting a flight that evening or even the next morning. BA Operations staff were now cancelling flights out of London City and they were trying to re-book passengers on alternative flights leaving from Gatwick the next morning. However, with further heavy snow falls on the way, there could be no guarantee that these repositioned flights would take place and his advice was not to travel at all if possible. Of course, to those passengers who were trying to get back home to Amsterdam, Frankfurt or Paris, this advice would cause them further delay and expense as they tried to find hotels in the area.

Although City Airport managed to keep its runways clear throughout this chaotic period, its operations were hampered by aircraft being out of position and flight crews out of time. Despite valiant efforts by ground crews to keep aircraft ice free and by terminal staff to keep passengers informed of developments, it was becoming clear that very little could be done in the wake of such a widespread disturbance. In the event, Heathrow, Gatwick

and Stansted were closed down for the best part of four days, an unprecedented event in the UK and one which produced many criticisms of BAA for the way they handled the crisis.

The report produced by the CAA into the disruption caused by the snow fall of 2010 revealed that while virtually all other UK airports came in for severe criticism for the way passengers were treated, London City Airport came out with a clean sheet. Many airlines also came in for severe criticism for not passing on information to their customers and in some cases refusing compensation to stranded passengers but again this was not a charge that could be landed at London City's management. Of course, it helped that LCY is a relatively small operation compared to the other London area airports but even so, from the author's own experience of being stuck in the same situation as many others that day, there can be no complaints. It was and still remains the author's favourite airport.

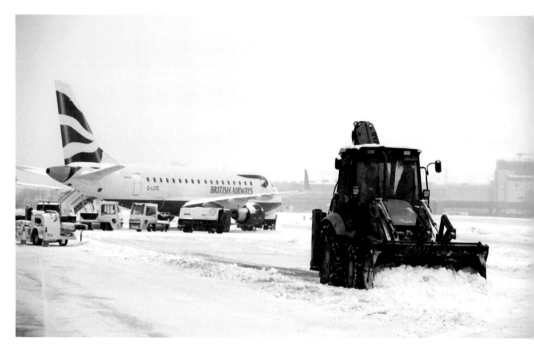

Clearing snow in 2010. (Chris Ratcliffe)

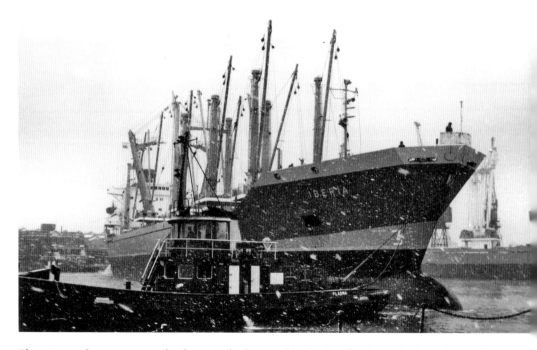

The winter of 2010 was not the first in which snow hit the Docklands; M.V. *Iberia* is seen here manoeuvering with the aid of the tug *Plasma* in King George V Dock during a snowstorm in March 1971. (J&C McCutcheon Collection)

Personalities

An airport's success is down to much more than the aircraft that fly from there and the bricks and concrete of the terminal and London City Airport is no different. We have already seen how the idea of the airport came about from the meeting between Reg Ward and Sir Philip Beck; how that idea was proven to be workable by Bill Brymon and Capt Harry Gee; and actually carried out Richard Sainsbury and his team from Mowlem. The takeover of the airport by Dermont Desmond was another turning point in the airport's history but none of these personalities impact on the travelling public like the airport's day-to-day management have to. With some 1,200 plus people employed at or by the airport, it is impossible to provide a profile on all the people and the various roles undertaken by the airport's many employees. However, any account of the airport celebrating its 25-year history would be amiss if it didn't mention the current management team.

At the top of the airport's tree is Declan Collier, who is the current chief executive officer. He is a relatively new figurehead, having been appointed as CEO in March 2012, but although he may be new to LCY he was formerly the CEO of the Dublin Airport Authority. Mr Collier replaced the long serving Richard Gooding OBE. Richard was first appointed as managing director under Dermot Desmond and later became its chief executive. He had been the very public face of the airport since 1996 and came with extensive experience from his previous post as CEO of Luton Airport. He stepped down earlier this year to become a non-executive director of the airport.

Also on the senior management team is Roy Griffins, who is the current chairman of Docklands Aviation Group Limited, and David Thomson, who is also one of the airport's directors. David was previously the chief financial officer and company secretary of London City Airport. He has been replaced by Patrick Burrows as the airport's

new chief financial officer. Patrick's appointment shows a possible new financial direction for the airport as his commercial background is from outside aviation and it is said that he will bring a more customer-focused insight into the business.

The new chief operating officer is Darren Glover, who joined London City Airport to set up and manage the Jet Centre. The Jet Centre has been one of the most successful operations at LCY which has seen a 400 per cent increase in movements in its first five years of operations. He later became the director of ramp services, with responsibility for some 200 staff working at the airport. As COO, Darren oversees the day-to-day running of the airport, which includes all of the terminal services, and those which impact on the airport's safety, operations and of course the Jet Centre. Meanwhile, Matthew Hall is now the chief commercial officer for London City Airport. His portfolio includes responsibility for the airport's relationship with the airlines. It also takes in all other commercial activity inside and outside the airport. This includes the retail outlets in the shopping plaza, the food and beverage concessions, all of the airport's advertising, marketing, public relations and car parking.

In addition to the management team, the Board of Directors also includes Scott Hatton, Raj Rao and Mehrdad Noorani, each of whom represent GIP capital on the Board. Meanwhile, James Kowalishin and Emmett McCann are the Board representatives of Highstar Capital.

Richard Gooding, the MD of London City
Airport.

The opening of the Jet Centre, with Dermot Desmond on the left and Richard Gooding centre.

Community Involvement

The management at LCY have always taken a very forward looking stance towards the local community. Not for them the confrontation those other airports have seen. Instead, right from the very beginning, the airport has tried to engage with the community of Newham and its surroundings. One of the key players in this has been the airport's Consultative Committee. This is a statutory body that was set up to safeguard and address residents' concerns. It is totally independent from the airport and it has acted as 'honest broker' when on the odd occasion complaints are made. It has its own web site and the minutes of its meetings are posted on there.

However, the airport also takes a more informal approach when engaging with the community by throwing open its doors and welcoming them in when the airport closes down operations over a weekend. These open days, believed to have been started by Richard Gooding, have proved to be very popular with the locals as the ramp area is transformed into a giant playground and performance area. With sideshows, fairground rides, giant inflatable slides and various local dance groups, the airport takes on a carnival atmosphere. All of the airport's staff right from the bottom to the very top of the tree are involved in the day's proceedings while the modern jet aircraft make way for wartime Spitfires and Mustangs. Meanwhile, skydivers parachute down onto the runways in spectacular fashion while aerobatics are performed by a variety of different stunt pilots. It is of course all very carefully controlled and the airport is soon put back to rights so that work can resume the next day but during this period of fun loving activity there isn't a stiff suit to be seen.

Community involvement doesn't stop there, though, for the airport has made significant contributions to the local arts scene and it sponsors a variety of other good causes in the area. This support for good causes in the local is appreciated by Newham Council, whose new offices now overlook the airport's activities from the side of the Albert dock.

Newham Council's offices, on the other side of Albert Dock.

Presenting a fund-raising cheque.

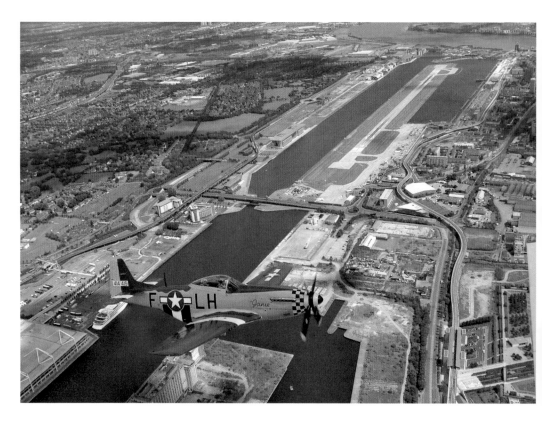

A Second World War Mustang flies over London City Airport during its Open Day.

Aerobatic aircraft.

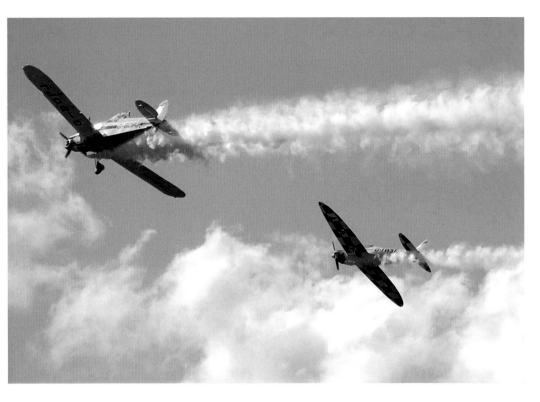

Formation aerobatics.

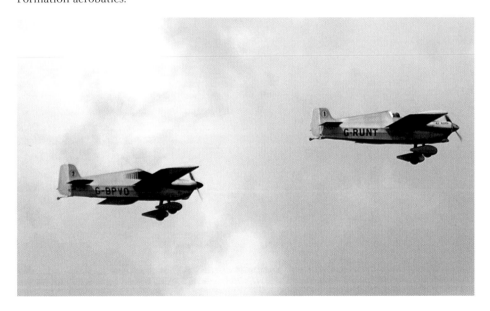

Formation display.

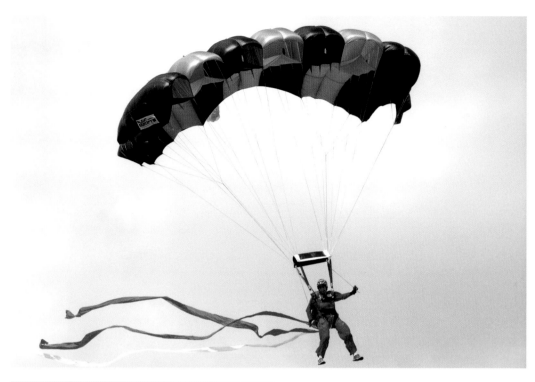

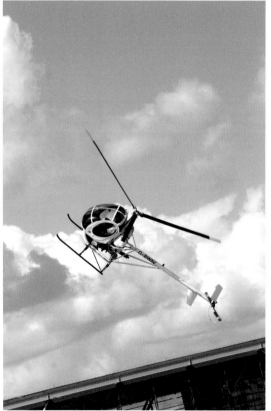

Above: Dropping into City airport by parachute.

Left: Helicopter aerobatics.

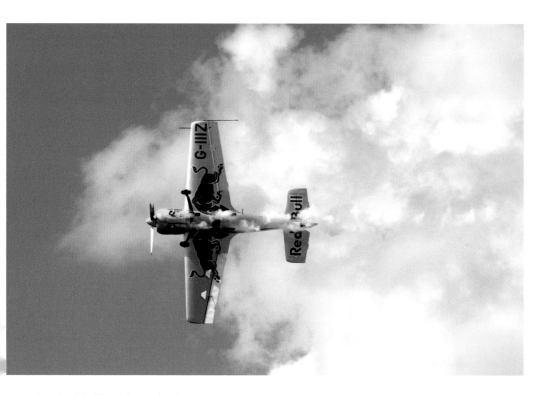

The Red Bull aerobatic display team.

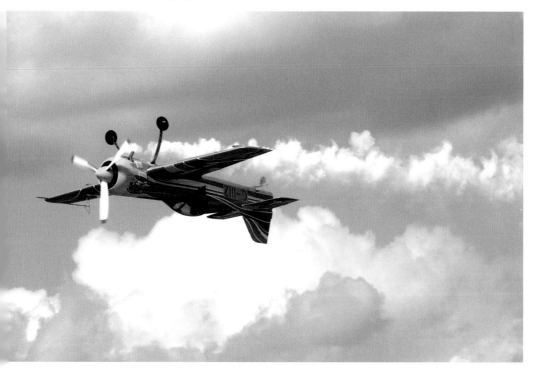

Upside down at London City – the Red Bull aerobatic display team in action.

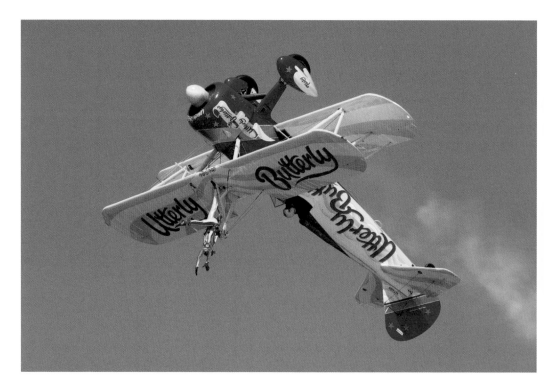

The Utterly Butterly wing-walker.

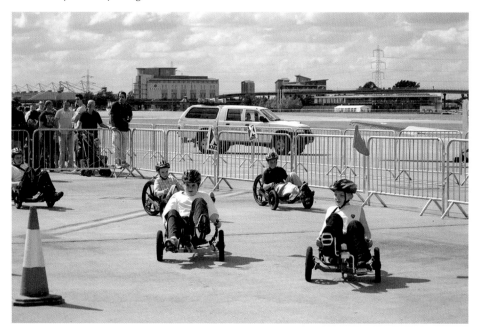

Go-kart racing at the City Airport Funday.

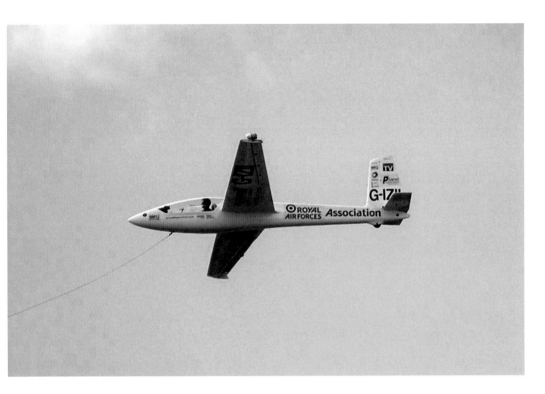

An RAF glider at the City Airport Funday.

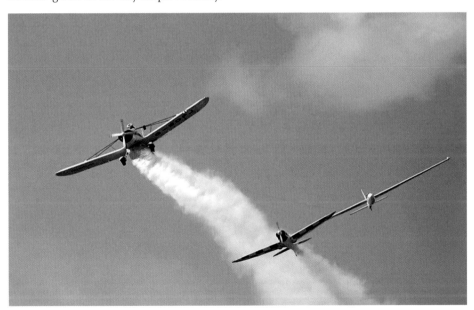

Towing the glider.

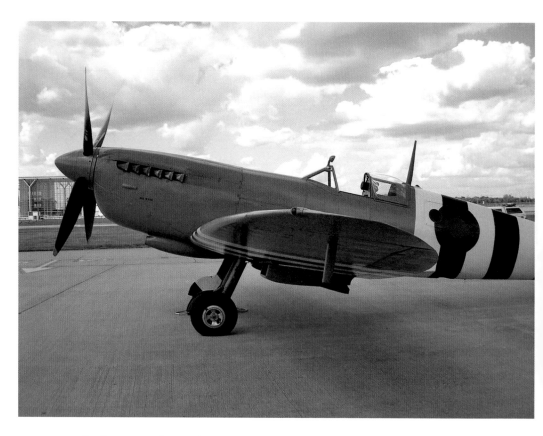

No air display is complete without a Spitfire to admire.

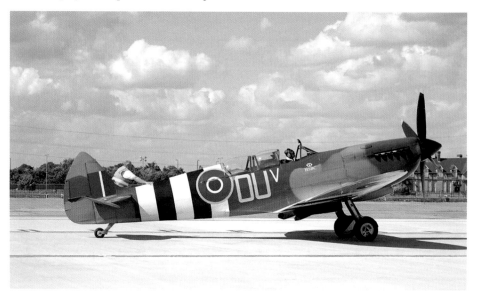

The Grace Spitfire rolls out.

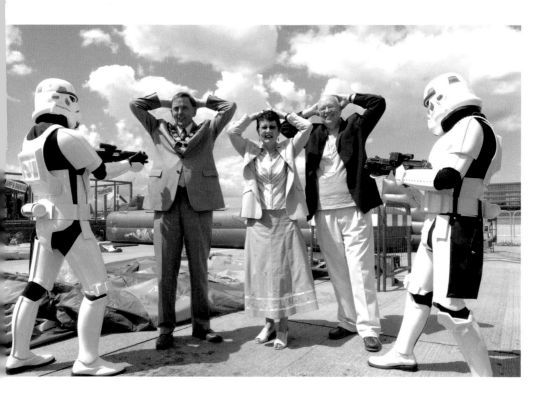

Star Wars troopers 'arrest' the Mayor and Richard Gooding, the Airport's then director.

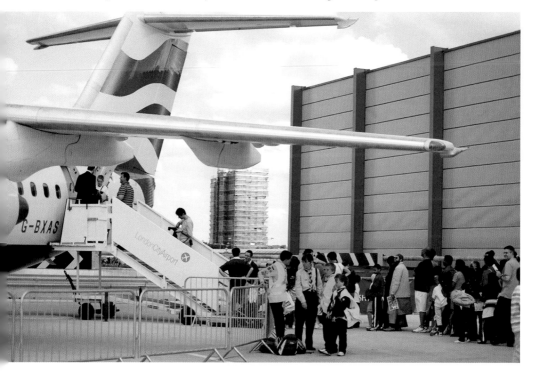

Showing the public inside a British Airways BAE 146 jet.

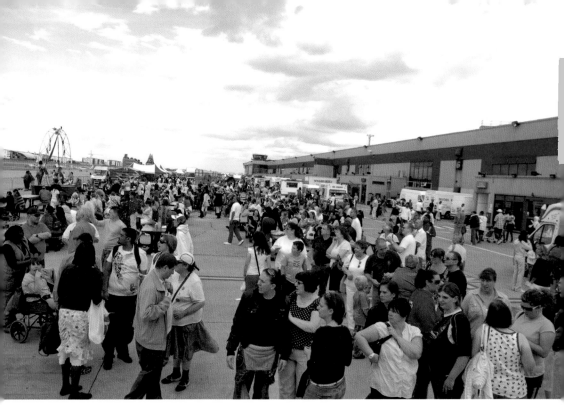

Crowds at London City Airport Fun Day.

Plans for the future

Following the publication of its new Master plan in 2006 to show how the airport might develop over the next 25 years, it is quite clear that the vision of the airport's founders is still apparent.

The airport's aim is to accommodate up to 8 million passengers per year by 2030. This is a far cry from the 200,000 passengers that were first forecast to use the airport some 25 years ago! In addition to this a further five new aircraft parking stands are to built over the wet dock, an extension to the Jet Centre for business aircraft operations and at long last a hanger for servicing aircraft. This would be a first for the airport's aircraft support technicians, who have not had the luxury of being able to service aircraft under cover, and it will greatly add to the airport's level of service.

Also in the pipeline is a new airport fire station and emergency support building. Hopefully, these items will never need to be used 'in anger' but such is the ongoing commitment of the airport's safety team that they will never let the airport out grow its safety requirements and responsibilities.

Perhaps the biggest or most ambitious plan they have is to build a parallel taxiway alongside and over the edge of the KGV dock in order to connect the terminal's main apron to the runway 28 holding point. This is deemed vital to the future of the airport if it is to play its part in helping to solve the capacity problems facing all of the airports in the South East sector. By having such a taxiway, aircraft will no longer have to wait for aircraft landing on runway 09 to back track to the terminal as the aircraft uses the runway for taxiing purposes.

If and when this new taxiway is built, it will represent a significant investment in the airport's infrastructure and enable it to offer greater flexibility to those airlines using the airport. Passengers too will benefit from this high

level of investment as there will be a new extension to the existing passenger terminal over the western end of the KGV dock.

Outside there will also be some changes to the airport's skyline as a new ATC centre is constructed to take over from the existing 'greenhouse' that overlooks the apron. Having squeezed myself up the narrow spiral staircase that leads to the existing tower, I would say this will be a most welcome addition for the ATC staff, who must always be on a diet!

Also in the plans for the future are a multi-story car park and a mixed use development on vacant land alongside the southern airport boundary. Car parking has always been a bit of a problem at London City and it is hoped that the new car park will address this problem but not at the expense of the DLR and other forms of transport.

All of these modifications will help to make the airport a much better place to fly from and give its customers a better experience. Local residents can be assured that there will be no plans to build a second runway or even to extend the present one, simply because there isn't room! Passenger capacity is also likely to be confined to present day numbers because the limited length of the runway dictates how big an aircraft can be to use it. 100 seats per aircraft seem to be the norm at the moment and there is nothing on the airframe builders' drawing boards to suggest otherwise.

From its very basic beginnings as a STOL port, London City has matured into a fully fledged airport in its own right. I have no doubt that Reg Ward and Sir Philip Beck would be amazed at how their idea for a city airport has taken shape and has now become an accepted part of the London scene. Indeed, the whole of the Docklands has been rejuvenated and as the photos show, the whole of the East End of London has changed beyond all recognition, helped even more so by the 2012 Olympics. Only the River Thames provides some sense of continuity and it is fitting that it does so, for without it there would have been no docks to convert in the first place.

Testing times: the arrival and take-off of the first Airbus A318 to use LCY. A318s now operate perhaps the most important route development at the airport: the British Airways service to New York's JFK.

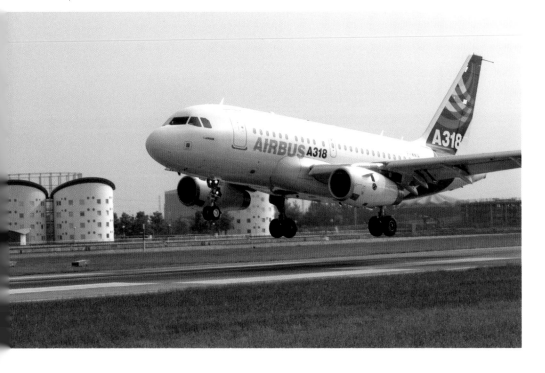

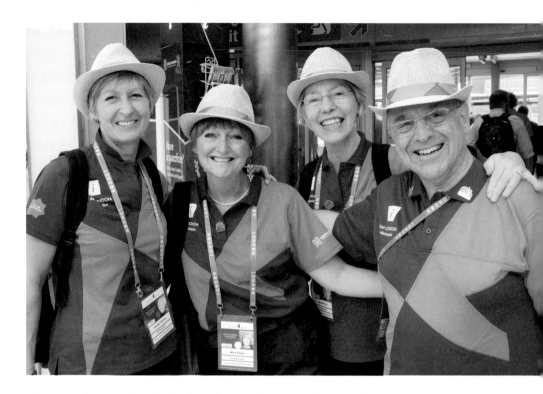

The 2012 Olympics have helped to change the East End of London beyond recognition; Olympic Ambassadors such as these gave a warm welcome to those arriving at London City.

The London City Airport Master Plan Summary, 2006.